ON DRAWING & PAINTING

ON DRAWING
& PAINTING

BY PAUL A. LANDRY

 PUBLISHED BY NORTH LIGHT PUBLISHERS
WESTPORT, CONNECTICUT 06880

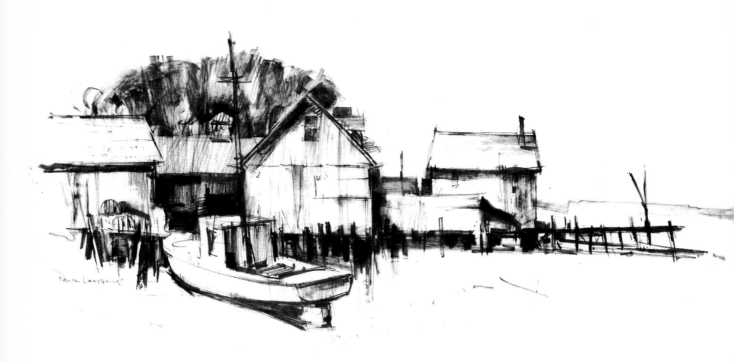

First published 1977 in the United States by North Light Publishers,
a division of Fletcher Art Services, Inc.
37 Franklin Street, Westport, Connecticut 06880.

Manufactured in Japan

Library of Congress Cataloging in Publication Data

Landry, Paul A.
 On drawing & painting.
 1. Drawing—Technique. 2. Painting—Technique.
I. Title.
NC730.L365 741.2'4 77-10609
ISBN 0-89134-012-2

Designed and edited by Howard Munce
Composed in Century Schoolbook by John W. Shields, Inc.
Printed and bound in Japan by Dai Nippon

INTRODUCTION

ONE OF THE HAPPY REWARDS that will come to me as author of this book is the opportunity to help you enter the world of drawing and painting. If you are serious, your life will never be the same — just *better* in many pleasurable ways.

I know by long experience, however, that it is necessary to curb the enthusiasm of newcomers — and to repeat that old and worn truism that says you must learn to walk before you can run.

With artists "walking" means drawing — and "running" means everything else: painting, etching, sculpting, wood cutting and all other graphic expressions. Just having an excellent color sense for instance is not enough to mask poor drawing — weak draftsmanship cannot be *decorated* away. You might pretty it up but you won't strengthen it or hide it. The only thing that will improve it is first, a desire to learn this most important basic and then a lifelong devotion to improving it. The one way to that goal is practice — never ending practice and *doing*.

Now having treated you to that short lecture (you'll be forever grateful) I can promise you that *after* your drawing begins to improve, your personality will begin to emerge and your work will start to reflect *you*.

When most people think of drawing they seem to limit it to the use of a pencil on paper. Not so. Drawing should be *under* and *in* and *around* and *part of* every artistic endeavor you undertake — no matter what the tools.

For Mary, a loving mother and wife

CONTENTS

CHAPTER 1

DRAWING

DRAWING MATERIALS:

In the beginning it is advisable to start with simple basic materials and build up as you learn their uses and peculiarities.

After you've become acquainted and begin to improve your skills you'll be quite impressed with the colorful and promising delights of a good art supply store. If you become a serious artist you'll look forward to visits as eagerly as some people do to a pastry shop.

PAPER:

An adequate (and the cheapest) pad to begin with is called "Newsprint" — it's what newspapers are printed on. Later you can graduate to better bond pads. I advise an 11″ x 14″ pad in the beginning.

PENCILS:

All drawing pencils are graded by the letters H or B. The "H" stands for Hard and they go up from the number 2 through 9. The lead gets harder as the number goes up. Hence you refer to them as a 2H and so on.

For some reason unknown to me, B stands for "Soft". Again, the numerals work upwards — the softer and blacker the lead, the higher the number.

Be sure to sharpen your pencils from the proper end or you'll lose the identification at the top end.

DRAWING MATERIALS

I suggest you begin with 4B's — they give a wide range of values from light greys to good darks. Meanwhile they hold their points well.

Equip yourself with a kneaded eraser which is a grey doughy rubber that you knead as you use it. Also buy a soft rubber eraser for harder pencil marks.

For sharpening, use a regular mechanical pencil sharpener or experiment with using a single edge razor or mat knife. Many artists learn to whittle a peculiar character into their pencil points. Trial and error will let you find yourself in this simple skill as it will in most art approaches throughout your lifetime.

In addition to the basic pencils above, also try stick and pencil charcoal. Charcoal forces you to hold the stick differently than one does in the "writing position" of a pencil. You'll find this new and awkward at first but you'll soon learn to like the feel and the different results.

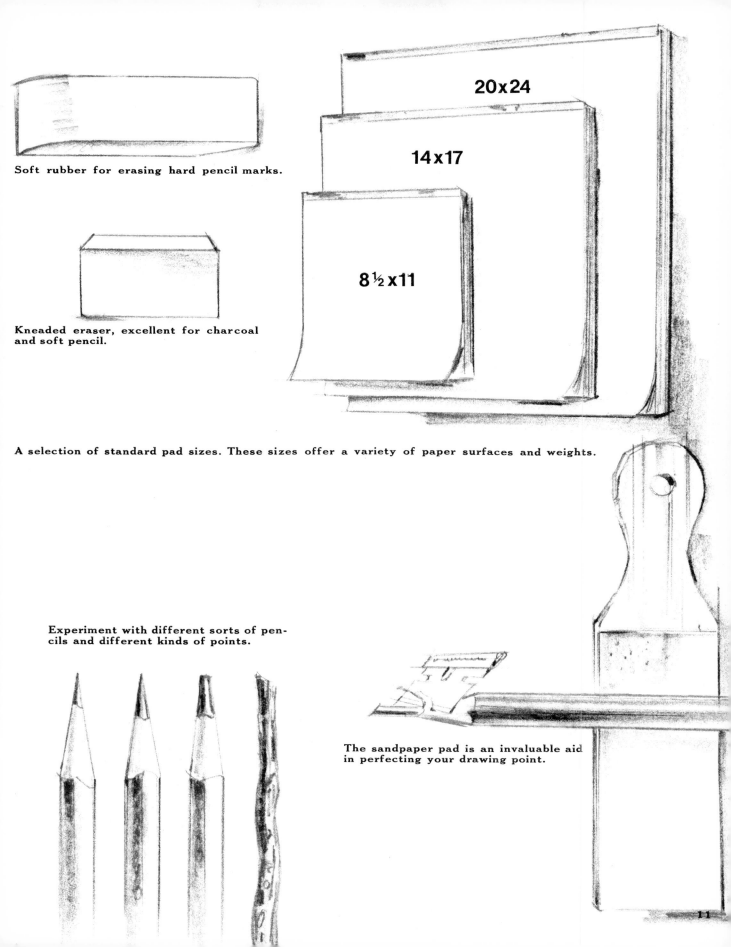

Soft rubber for erasing hard pencil marks.

Kneaded eraser, excellent for charcoal and soft pencil.

20x24

14x17

8½x11

A selection of standard pad sizes. These sizes offer a variety of paper surfaces and weights.

Experiment with different sorts of pencils and different kinds of points.

The sandpaper pad is an invaluable aid in perfecting your drawing point.

11

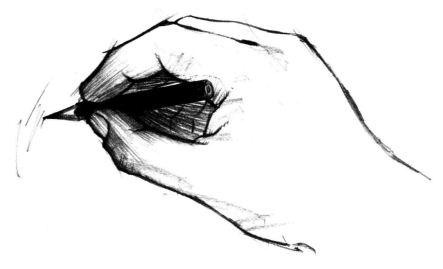

Whichever you settle down to using you'll be dealing with strokes: short to long — sensitive and fine to broad and bold. And finally, solid masses of value. I find the following ways work best for me. For controlled strokes hold the pencil as in figure 2, the same as you do for writing. The little finger is the major pivot point for most strokes. In this position the motion is mostly with the wrist. Longer, sweeping strokes are made

WARMING UP:

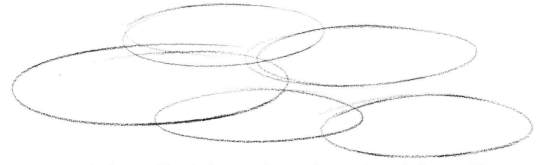

Artists are like pitchers getting ready to go into a ball game. They throw a few balls in the bull-pen to warm up their arm before heading to the mound. The artist should loosen or warm up his arm, too. Here are some exercises to help you. They also help train the arm to draw through and develop rhythm.

Start with figure 5A, drawing a few pages of ovals. They don't have to be perfect, just swing your pencil around and through. It's all arm movement with the small finger gliding over the paper. Draw some from right to left, and then some from left to right. Now do some on varied angles (see B). The whole idea is to get loose and into the swing of things. These exercises might bring back memories of learning to write in school.

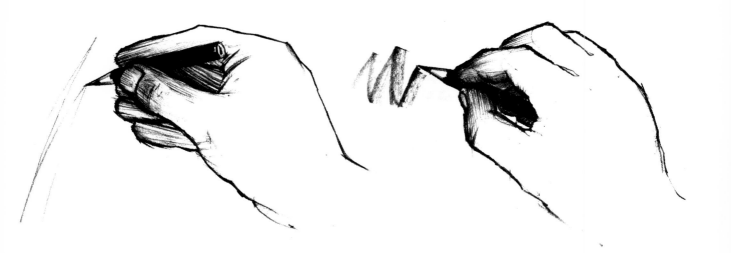

easily with the hand turned over (see figure 3). This gives flexibility of movement. The fingernail of the little finger glides over the paper. This motion includes wrist and arm. For solid value masses, hold the pencil as shown in figure 4, cradling it with the fingers underneath. The pencil lead lies flat on the paper. The weight will be resting on the fingernails of the fourth and fifth fingers.

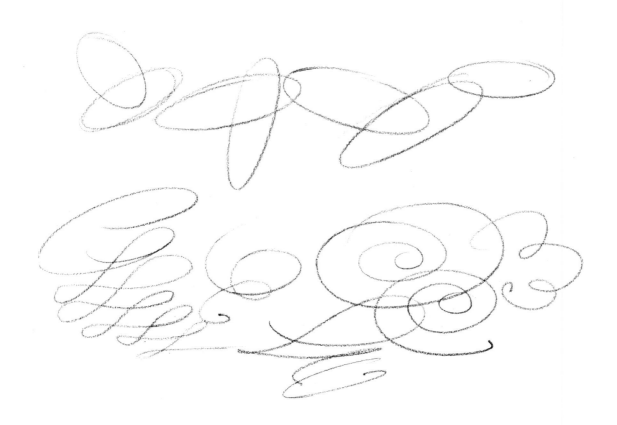

BASIC FORMS:

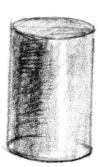

FIGURE 6

Generally, everything we see contains one or more of the following basic form, (figure 6), cube, sphere, cone or cylinder, or a combination of the three basic forms, (figure 7). We see these basic forms everywhere. A ball or an apple is basically a sphere. This book is a cube. A Christmas tree is a cone, the pencil you draw with is a cylinder. When you learn to recognize basic forms, you'll be aware that everything you draw has three dimensions; not only height and width, but also *depth*. You will be aware that it occupies space. Make it a mental practice to convert objects into their basic form as you observe the passing scene.

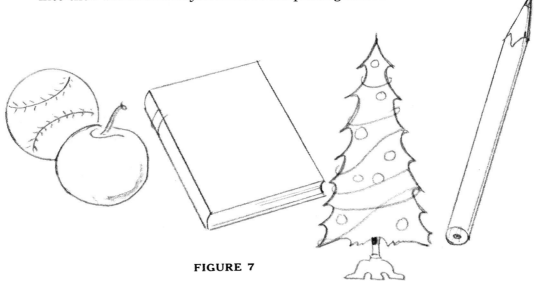

FIGURE 7

15

LINE DRAWING:

"Line drawings" are simply that, the drawing of lines. Lines have length only. We use lines for constructing a form; for studies for paintings and as finished drawings. No matter the medium or the end result of a picture, chances are that you'll begin with lines. Actually, there are no lines in nature. There are just shapes, the overall appearance of something. There are boundaries to shapes, and you'll see these if there is a light against dark or dark against light value contrast. To establish these boundaries we use lines, though they really don't exist. When we draw lines to represent something, we should make them continuous, going somewhere, in a specific direction and relative to each other. When drawing a tree we should start from the base of the trunk. When drawing the branches and foliage masses, they should be relative to the trunk, the main action. We draw with the growth of the tree. Always draw the main or known quantity first and relate other lines to it. (See figure 8).

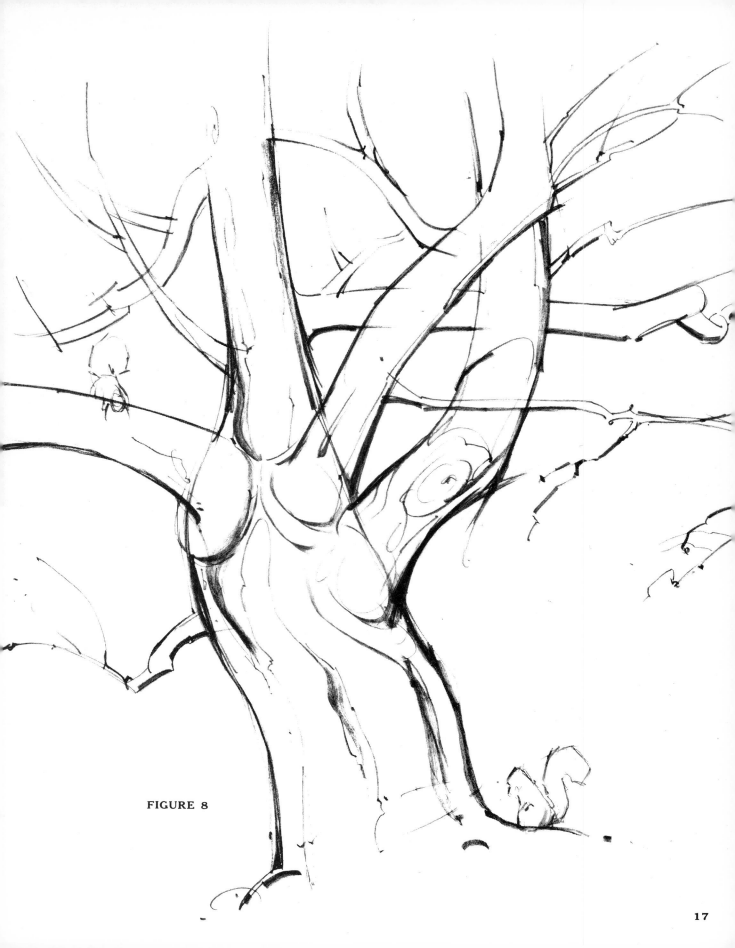

FIGURE 8

DRAWING THROUGH AND RELATING

Capturing the solidity and rhythm of a form comes from the practice of drawing through. For me, that's imperative. The first two dimensions, the height and width of a form are easily seen and drawn by the beginner. Generally the third dimension, the depth or thickness, is ignored.

To achieve the feeling of bulk, the pencil should not only draw up and down, but around and *through* hidden areas. We should draw and construct things as though they were transparent. The pencil should actually sense the form to show that it exists in space as in figure 9. Relationship of continuous line will give rhythm and unity to a form. As mentioned previously, every line you draw should be related to another line, in direct or close relationship from somewhere to somewhere. Whatever you draw, you'll find line relationship, from the head to toe of a figure or from the trunk to the tip of the tree. Figure 8 illustrates this point.

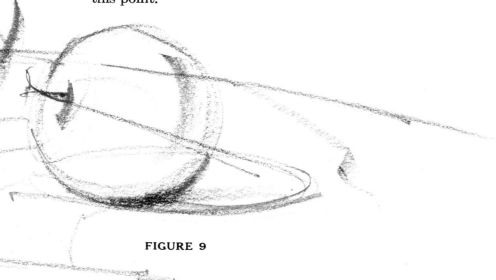

FIGURE 9

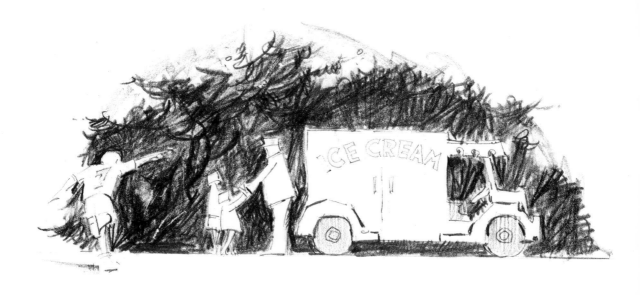

SHAPES AND VALUE

Seeing things as shapes and value is the first step in drawing and painting. A child who cannot yet read, can immediately identify an ice cream truck, (figure 10). Its shape, the basic overall characteristic of something is what the child recognizes, in this case, a short cube shape. The shape is identified by its contrast or lightness against the surroundings, meaning its value. For example, note the light-colored truck against the dark background foliage.

Before you draw something, observe and recognize its shape. Look for its basic identifying characteristic. Is the object round or square, tall or short, fat or thin, and so on. Drawing in the detail will then become easier.

DRAWING SHAPES

When you draw, be aware of overall shapes, the external surface or contour of an object. Try to observe the relationship of one shape with another. Remember, the only way we see shapes is by the contrast of light to dark values. That's how the artist brings out that particular shape's character.

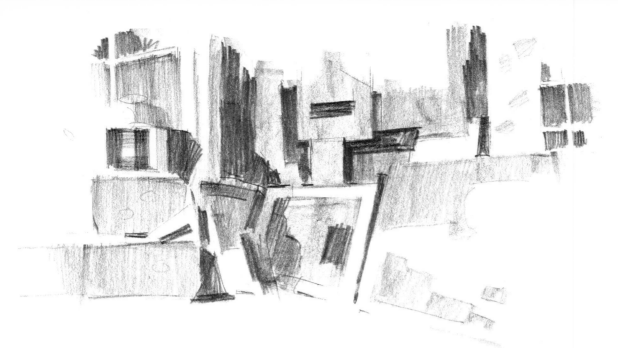

FIGURE 11

Figure 11 and figure 12 are studies of shape patterns. The subject matter in this case was not important. The training of the observant eye is. Where you start to draw is arbitrary. The first drawing is a studio corner, the other, a studio sink. One shape was observed and drawn and others were related to it in size, configuration and value. The value relationship is the total effect.

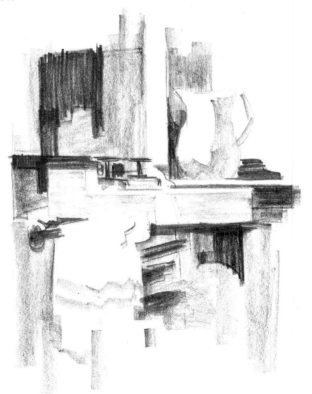

FIGURE 12

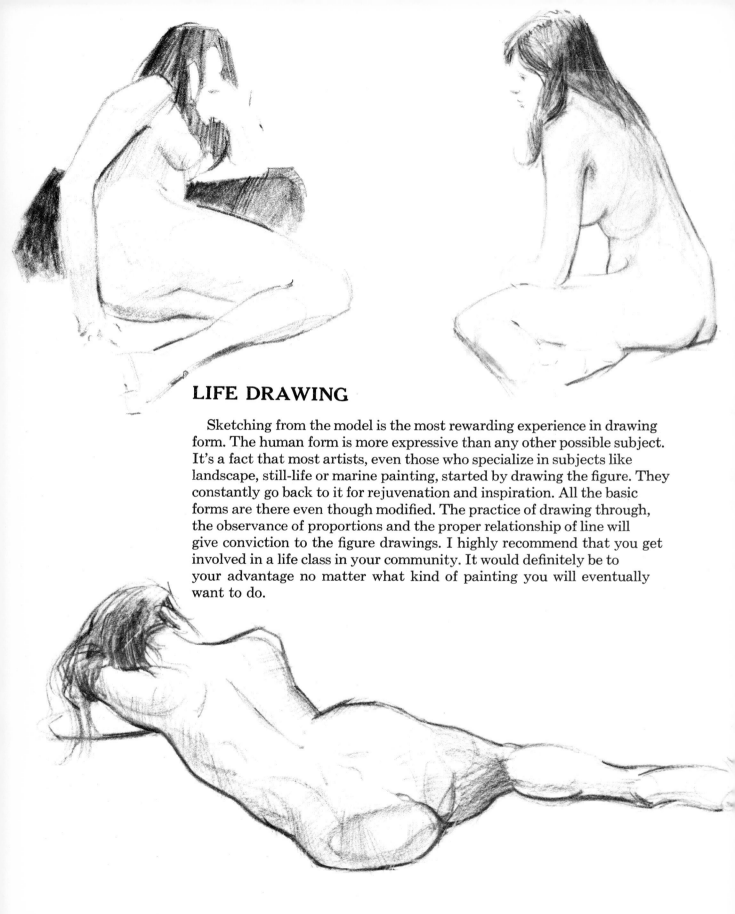

LIFE DRAWING

Sketching from the model is the most rewarding experience in drawing form. The human form is more expressive than any other possible subject. It's a fact that most artists, even those who specialize in subjects like landscape, still-life or marine painting, started by drawing the figure. They constantly go back to it for rejuvenation and inspiration. All the basic forms are there even though modified. The practice of drawing through, the observance of proportions and the proper relationship of line will give conviction to the figure drawings. I highly recommend that you get involved in a life class in your community. It would definitely be to your advantage no matter what kind of painting you will eventually want to do.

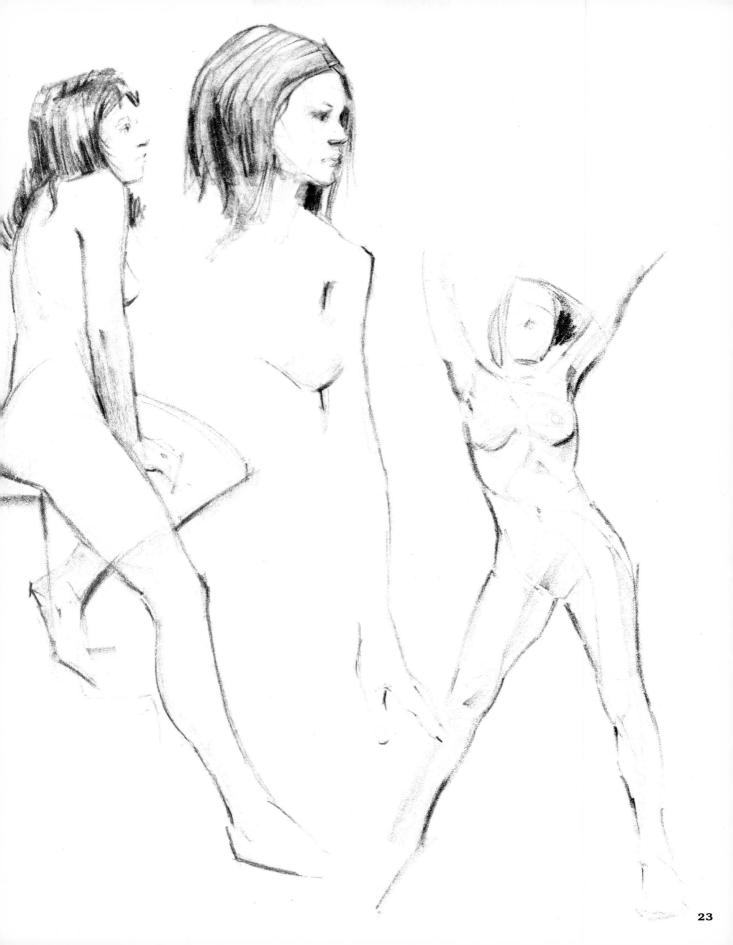

WORKING SKETCHES

An important step before painting is to familiarize yourself with your subject. You can accomplish this by just looking and observing and then, selectively, sketching the essence of your subject. You don't have to go into great detail. To me, the most interesting drawings are not those polished and finished from border to border. Working sketches that have the look of fresh spontaneity are very desireable. We not only have something that leads to a painting, but we also have a salable drawing.

Figure 14 is an example of a working sketch. I started drawing the area that first attracted me. In this scene, it was the piling patterns of the dock, shacks and arrangement of foreground boats that lead the eye into the picture. The surroundings were lightly touched on, indications that only complement the main idea.

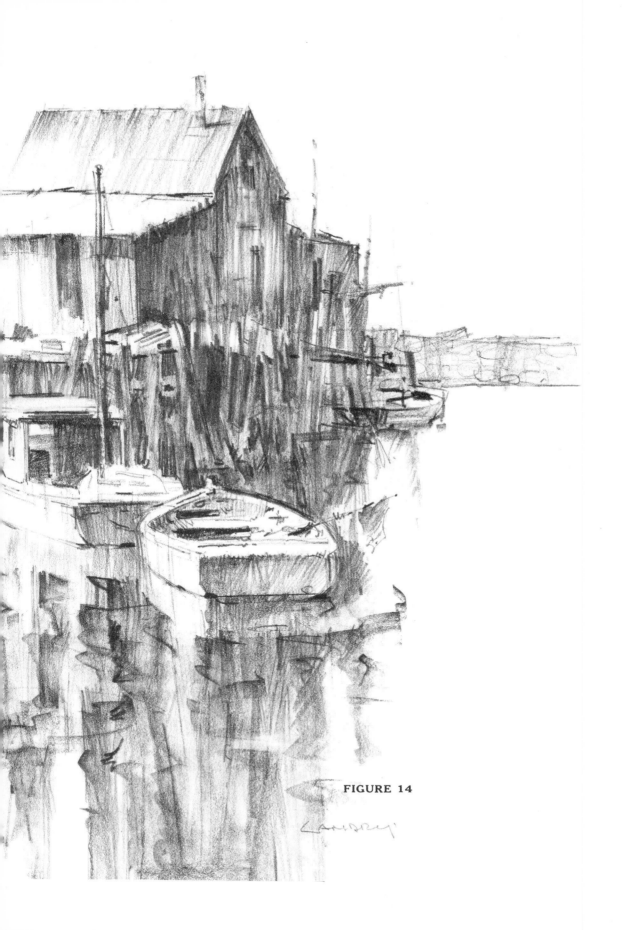

FIGURE 14

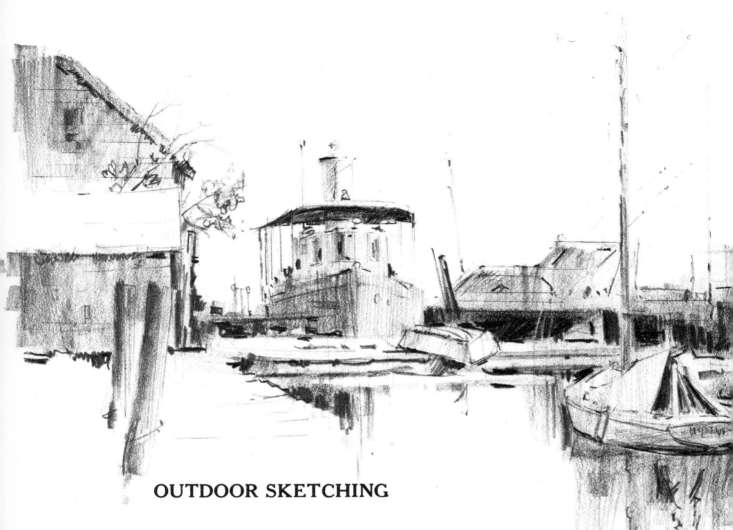

OUTDOOR SKETCHING

One of the most frustrating aspects of outdoor sketching is deciding where to begin. In nature we are often overwhelmed with so much to see and select from. Simplification, is the answer. Look and analyze before beginning to draw. Do not try to capture all the secondary things — the small shapes and minute details. It is more important to go after the "big shapes" and, to establish a descriptive and interesting pattern of values. If you proceed in this way, the refining of your drawing will be easier.

In figure 15, the establishment of big shapes were initiated first. Buildings, docks and land areas were quickly blocked in with the flat side of a 5B pencil to a middle value between black and white. In figure 15A the darks were determined — the building shadows and the area between the pilings. The rendering of textural details was finally put in. The big pattern of shapes and values that were first established were held through the whole drawing procedure.

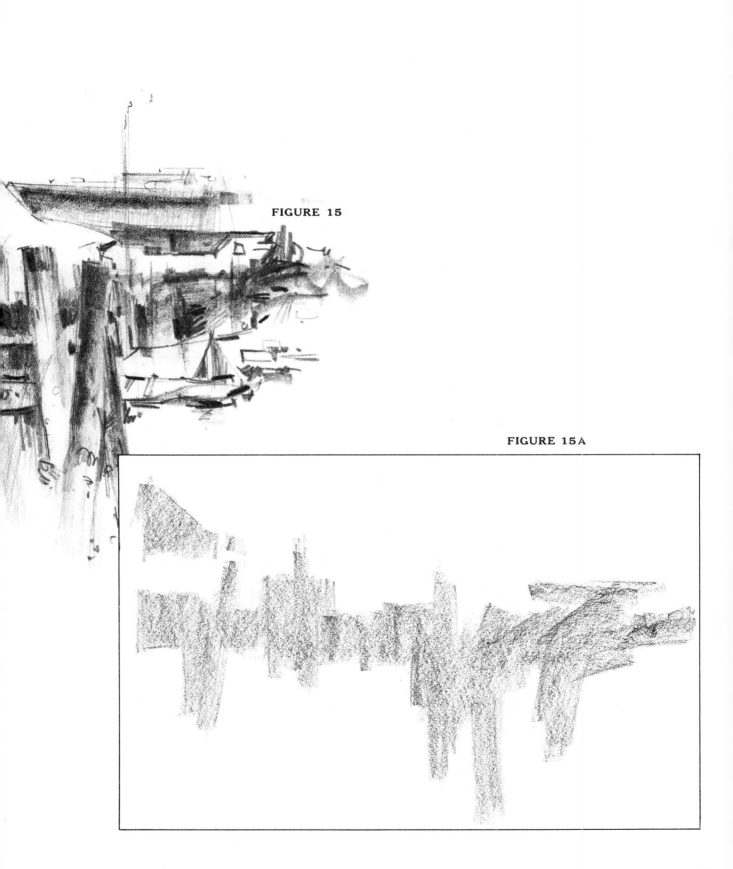

FIGURE 15

FIGURE 15A

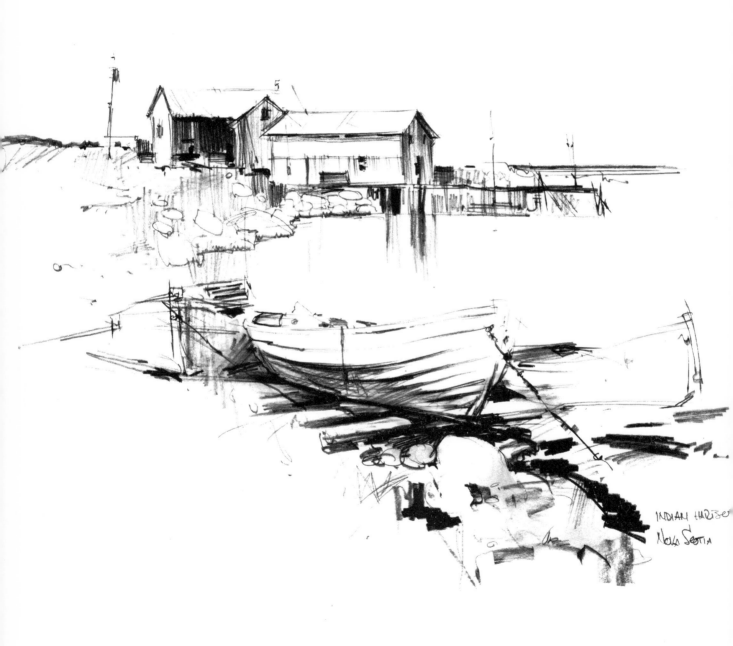

INDIAN HARBOR
Nova Scotia

CHAPTER 2

PERSPECTIVE

The word "perspective" has the same frightening effect on most people as the word "mathematics." There is nothing really complicated about the principles of perspective. It isn't as terrifying as the word implies, especially since it is only the basics that are our main concern as painters. For example, a technical illustrator is concerned with mechanical accuracy. If a painter were similarly involved it would certainly hamper his or her creative ability as a picture maker. So relax. As the saying goes, "rules are made to be broken," even knowingly! We can violate the principles to achieve more exciting compositions. This again separates the creative painter from the technical illustrator. We must, however, know and understand the basics for creditable results.

In essence, perspective is a matter of one simple fact: *the further away a form is, the smaller it becomes.* And, the height, width and thickness decrease relatively. With this in mind, let's study the following demonstrations to expand this principle. By applying these concepts to any object, your painting of form will have a feeling of existing in space.

ONE POINT PERSPECTIVE

Before we proceed, get yourself a corrugated box like the one I've used in figure 1. Press the flaps inside and move it around as the following text indicates.

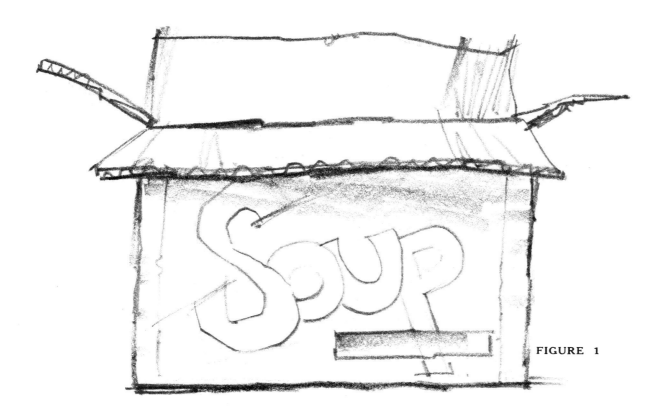

FIGURE 1

In figure 1, we view only one side of the box which we will call the front plane. It has only two dimensions; height and width. Little depth is evident. Still looking straight on and when viewing the box as in figure 2, on a higher elevation, we start to see inside the box, or the top plane. The level parallel lines or top side edges appear to recede to the rear edge, being farther from the eye, the rear edge will seem shorter than the front edge — in reality of course they are the same. If we extended the parallel lines that are horizontal, they would appear to converge and meet at a distant point over the top of the box. This is called the *vanishing point*. This point is on the horizon or eye level. Depending on your view point, vanishing points can be anywhere along these levels.

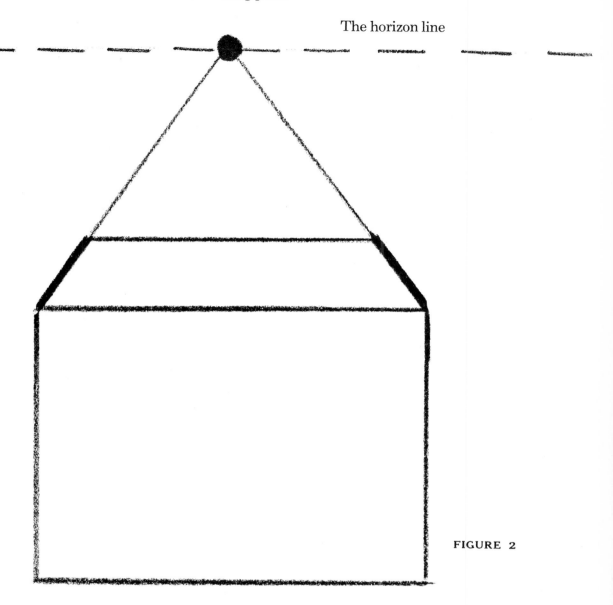

Vanishing point

The horizon line

FIGURE 2

Horizon line and eye level are interchangeable. The horizon line is just that. The best example is where the sky meets a large flat body, such as the sea or desert. Generally the horizon is obscure. For instance, in a closed room or hilly country, we can't visualize the natural horizon. In this case, we find our own eye level, and it is more factual than the natural horizon. *The true horizon is the level of your own eyes when you're looking straight ahead.*

Instead of looking over the box (figure 2) and seeing only two planes, front and top, let's change our position and look at it on an angle. (Figure 3.)

From this angle we now have three planes visible, front, top, and side. We see from this position that all parallel lines — the edges of the box that are opposite each other — appear to come together as they recede. Due to the angle, the top and side plane edges now go to the right side. The front plane edges now converge toward a second vanishing point. As you will note, both vanishing points are on the horizon, or eye level. You will also observe how the hidden planes, bottom, left side and rear, are also related to their perspective vanishing points. A drawing made from this angle is called two-point perspective.

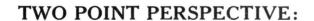

TWO POINT PERSPECTIVE:

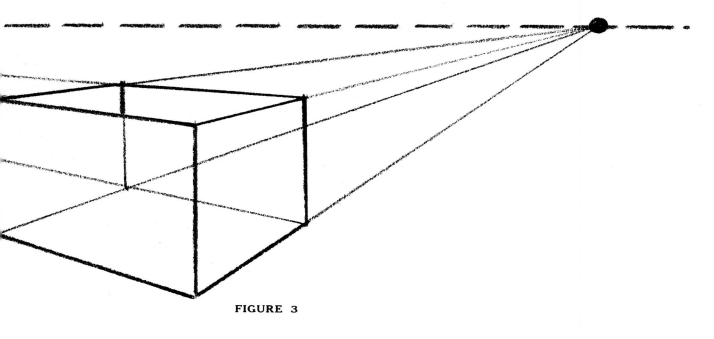

FIGURE 3

In two-point perspective, the parallel lines converge toward vanishing points on an eye level. Knowing this, you can now relate other details of the box. With the flaps out (figure 4,) note how the construction lines in the flaps and also the smaller paralleled shapes on the sides converge toward the vanishing points on the right and left sides.

FIGURE 4

FIGURE 5

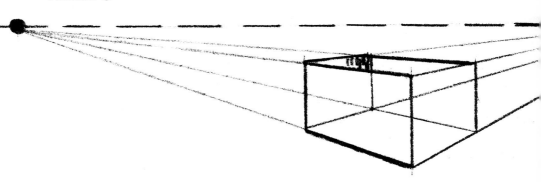

ABOVE OR BELOW EYE LEVEL:

FIGURE 6

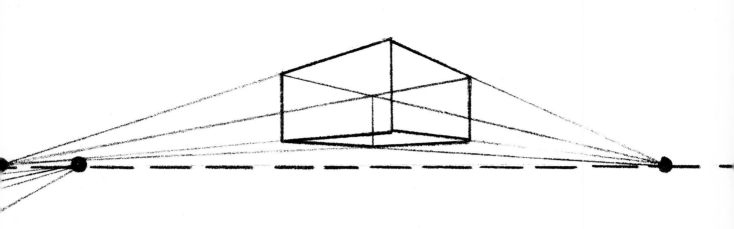

As demonstrated in one point perspective, the true horizon is at your eye level. If you view the box from above, the eye level will be high. The convergence of construction lines would relate respectively to vanishing points on this eye level. This gives the impression of looking down at your subject. Now in the same picture, say you place another box, perhaps on a high table. Being above your eye level, the parallel lines would converge downward, toward the same eye level. Note that we only have one eye level. Depending on where the objects are vanishing points can be anywhere on the eye level. (Figure 5.)

When your eye level cuts through an object, the parallel lines can converge downward and upward from the same object. The parallel lines above the eye level will converge downward. Below your eye level they ascend until meeting at a vanishing point on the eye level. (Figure 6.)

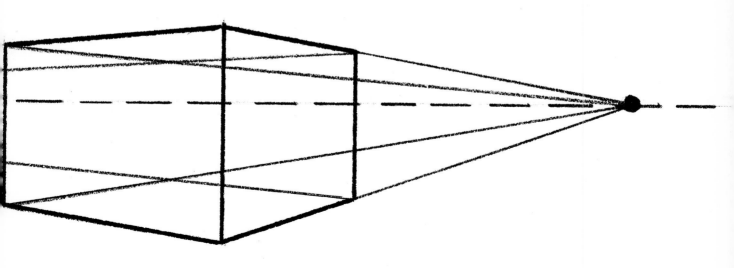

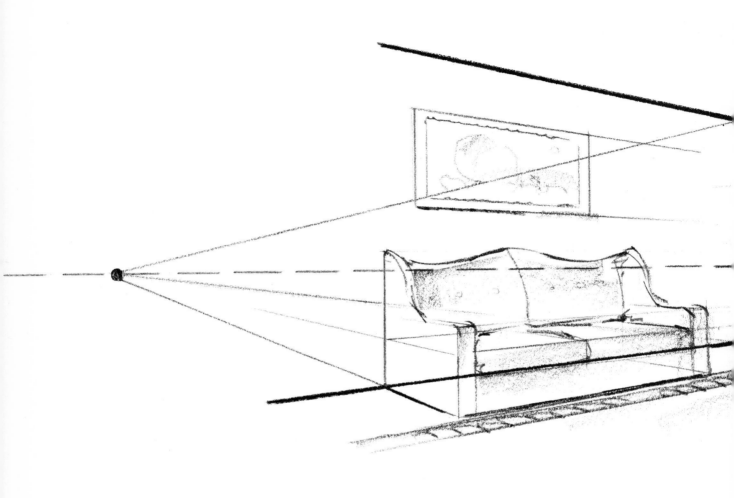

THE INTERIOR:

An interior follows the same principles that we observed with the box. Now, however, we are on the inside. In this example (figure 7), we view the corner. Both walls recede and the parallel lines of each converge toward vanishing points. In addition, all lines that are parallel — furniture, rugs, windows and so on — to a wall, will have similar convergence.

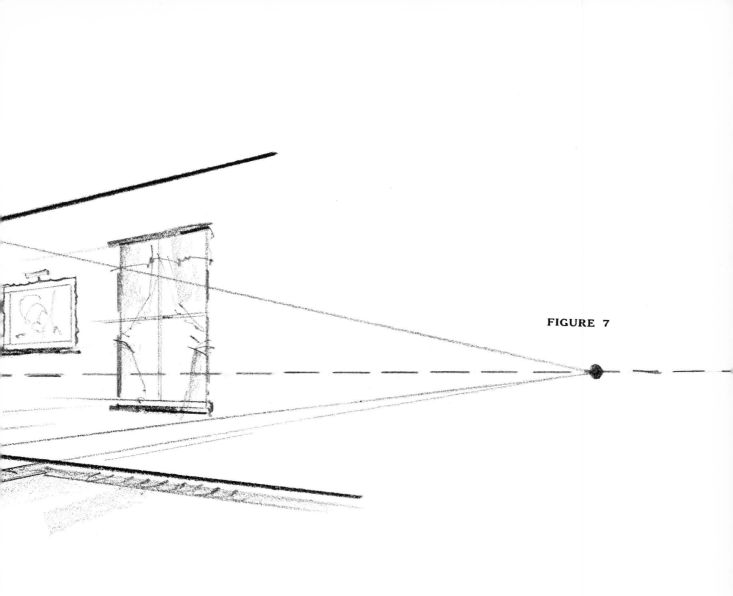

FIGURE 7

THE CIRCLE:

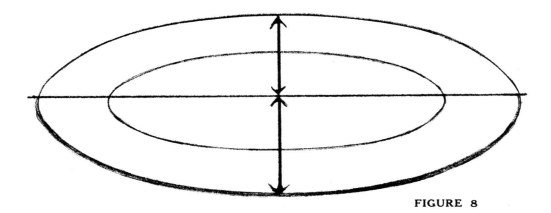

FIGURE 8

A sphere or circle such as a dinner plate changes its appearance to an elliptical shape, a proportion that's shallow in depth to its length, when viewed on an angle.

If you drew a horizontal and vertical line through the center of a plate (figure 8), and hold it on an angle as illustrated, you'll find that the front half is deeper than the back half. Note also the depth of the front rim in regard to the rear . . . it's wider. Again the principle, the further away a form is, the smaller it appears.

See how the same principle applies to the drawing of the lighthouse (figure 8A) and note how you look *down* on the ellipses when they occur below the horizon and *up* to them when they appear *above* the horizon.

Plastic templates with ellipses of varying degrees stamped out are available at most art supply shops.

These allow you to trace a perfect ellipse. They are invaluable for commercial artists and draftsmen but of little help to a painter since they are limited in size.

Also, as a painter, the drawings need not be as precise, but you will want to know how to solve this drawing problem without instruments.

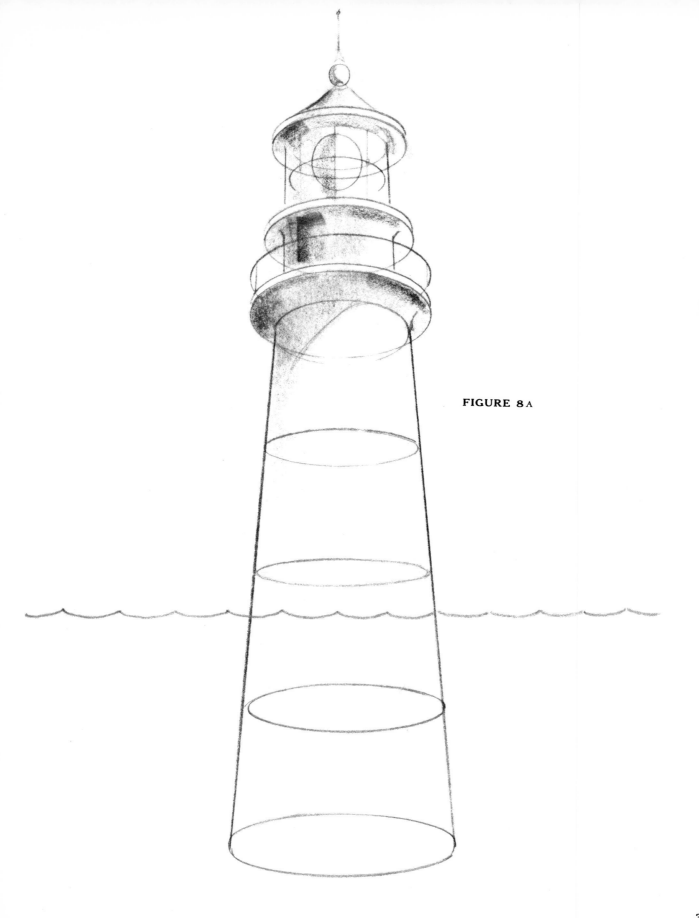

FIGURE 8A

CHANGING VANISHING POINTS AND INCLINE PLANES:

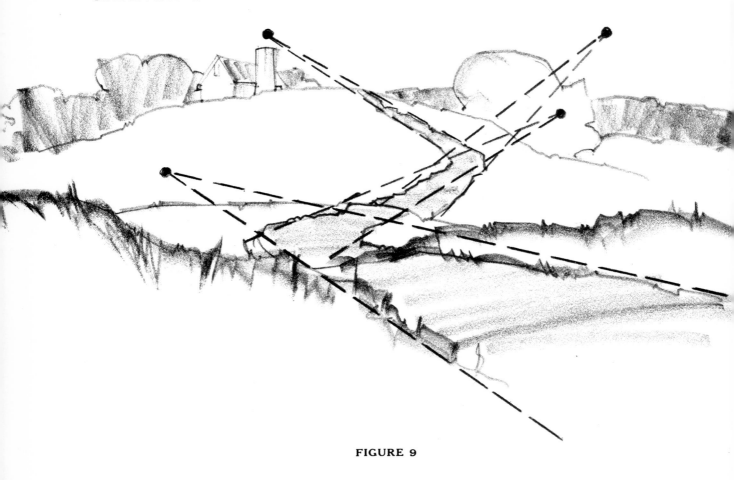

FIGURE 9

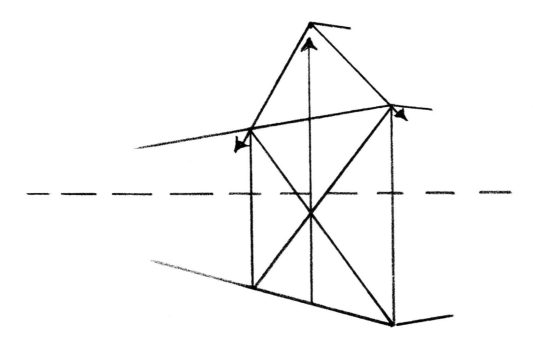

FIGURE 10

As mentioned previously, there can be many vanishing points on an eye level. This depends of course, on the positions of these level forms in your picture. In nature there are many deviations, from the normal level plane due to hills or land contours. Things that are on these contours of rolling landscape can have vanishing points anywhere. I've demonstrated in figure 9 how roads on hills relate to the contour of the land. The steeper the slope, you will note, the higher the vanishing point. In this case, it is up in the sky. In the foreground, the road slants downward and the vanishing point is well below the natural eye level of the picture.

Inclined planes do not, of course, lie parallel to horizontal or vertical planes, but they do have a direct relationship. For instance, the perspective of the pitch of a roof is sometimes a problem. Here's how to solve it, without going into complicated procedures. After sketching out the main box-like structure of the house and placing it in the perspective, you can find the pitch of the incline planes by extending lines from the corners which form an "x". (Figure 10.) Now, extend a line vertically parallel to the sides of the house across the center of the "x" to the apex of the roof. The distance to the top depends on your observation. From this point, extend lines downward to meet the roof corners. The slopes of the roof are now in direct relationship to the perspective of the house.

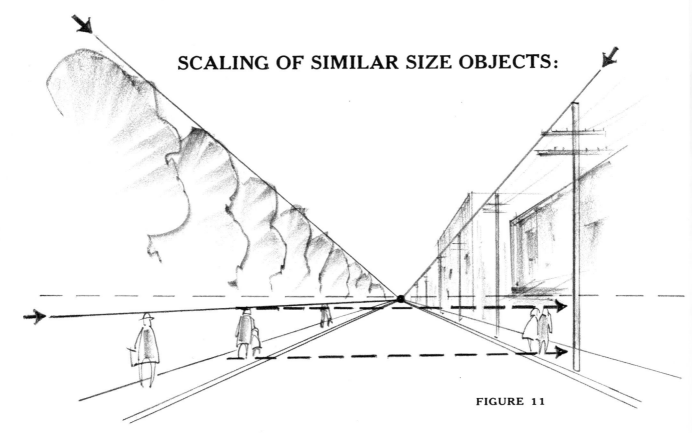

SCALING OF SIMILAR SIZE OBJECTS:

FIGURE 11

Objects of similar size can be scaled, as demonstrated in figure 11. My illustration is a street scene lined with trees, telephone poles and people. For simplification, only one point perspective is used. First, locate the eye level or horizon line, (the light dashed rule.) Now establish the height of the first foreground tree, pole and figure. Secondly, draw lines through from the height of the first tree, pole and figure to the vanishing point on the eye level or horizon line. This will give the proper height of all the objects in line that are similar in height. From these perspective lines you can locate any object of similar size or objects above or below it, like the buildings on the right-hand side or the figures across the street. The dashed lines drawn horizontally from a related figure or at any point from along the perspective lines illustrate this idea.

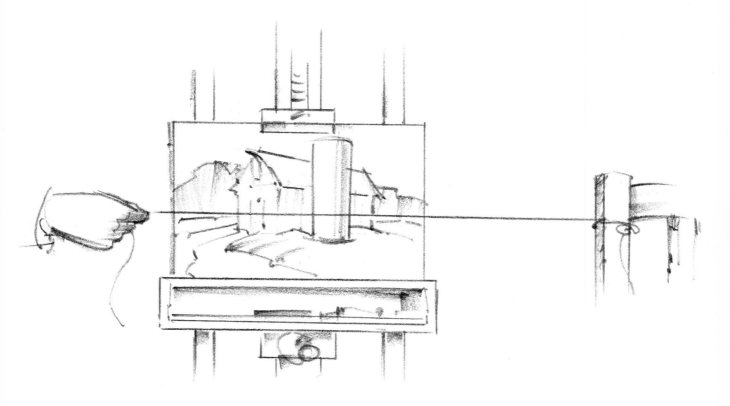

FIGURE 12

In figure 12, I've demonstrated how to check the perspective of things while painting. All you need is a length of string. Generally, you'll find that vanishing points are not always within the confines of your canvas and if you want to check the perspective of an object, like a building, just tie one end of the string to a chair back or any other object that is similar in height to the eye level or horizon line of your picture. The point where you tie the string end will be your established vanishing point. Tighten the string on the eye level and then raise or lower it to check perspective.

Once you understand the principles of perspective and put them into practice you'll find it unnecessary to use such a mechanical approach every time. You'll only need such construction lines when your observations are in doubt. You'll also find that your drawing ability will increase to such a degree that everything will naturally fall into its relative perspective.

CHAPTER 3

COMPOSITION

Composition is an arrangement of elements within a picture space to form a unified whole.

The way you arrange your subject matter depends on your conception. If you wish to convey that idea to a viewer, how you select and arrange your elements are all important. Basically, composition is just a matter of learning to avoid things which tend to weaken the harmony of your idea.

In our daily life whether at home, work or play, we are all arrangers in a way. We arrange our thoughts and ideas and put them in order. We are very selective in what we do. For example, the homemaker selects and arranges furniture, considers proportion and positioning and color balance. Furniture too large will crowd the room, and if too small, there will be a feeling of emptiness. The builder has to plan his construction making sure everything is in its rightful place to avoid a house that is weak in structure and design. And a winning athletic team is always one that works well together as a unit.

As I mentioned previously I'm mainly interested in teaching you how to avoid things that will weaken your idea. These principles are traditional guide lines to go by. It is important to be aware of them. They should not be adhered to completely, as tied-down rules tend to stifle ones creativity. Your own individuality should come into play in composition. If you were to observe a group of experienced artists working together, you'd see how differently they would compose the same subject. But, however different, everything would be arranged in a cohesive, balanced and unified way.

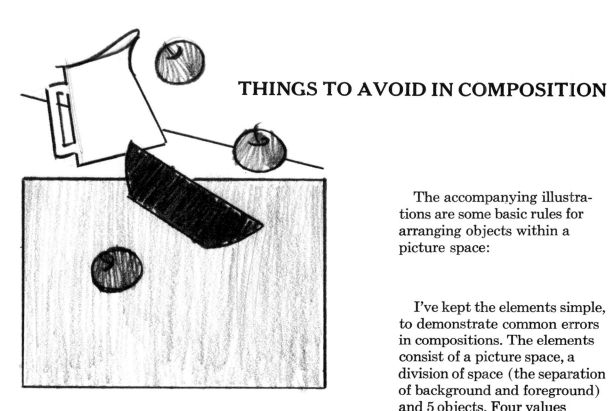

THINGS TO AVOID IN COMPOSITION

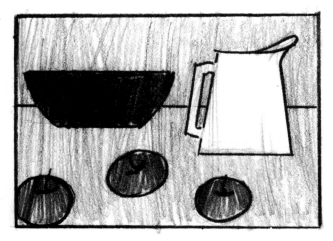

FIGURE 1

The accompanying illustrations are some basic rules for arranging objects within a picture space:

I've kept the elements simple, to demonstrate common errors in compositions. The elements consist of a picture space, a division of space (the separation of background and foreground) and 5 objects. Four values were chosen for each of the picture elements: black, white, a light gray and a dark gray. Value planning is just as important as the arrangement of elements.

In this composition (figure 1), the objects are scattered about in such a way that a spotty arrangement results. Overlapping some of the objects would give unity to this arrangement.

FIGURE 2

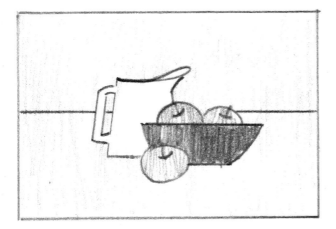

FIGURE 3

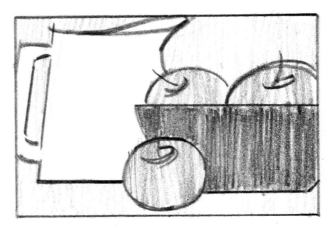

In this sketch (figure 2), the objects are overlapped and it does give a feeling of unity. However, the shapes are so tightly bunched they become confusing. Also, the group is mechanically centered in the picture space like a bull's eye. The division of space is too equally divided. Opening up the objects and varying the background spacing would be better.

Figure 3 is an arrangement that overwhelms the picture space. In fact, there is little space left. Everything is wedged in. A happy medium between c, and d, is more appropriate.

FIGURE 4

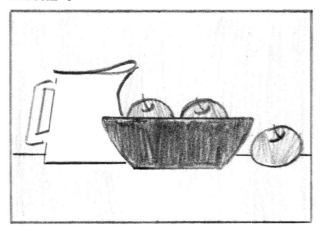

FIGURE 5

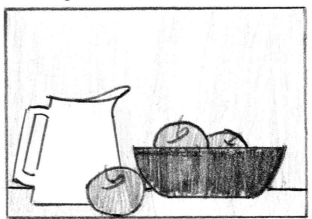

The scale of the still-life objects in figure 4 is in better balance here. But, the objects are lined up horizontally, causing a monotonous arrangement. Lining up vertically would create a similar problem.

The positioning of objects in figure 5 have greater variation, but now everything is crowded into the bottom. The upper part of the picture space is empty, making the composition bottom heavy. The same problem would result from crowding objects into the top portion.

FIGURE 6

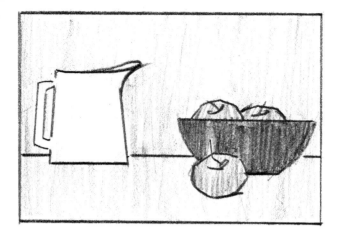

FIGURE 7

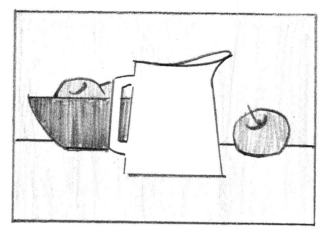

Moving the objects as shown in figure 6 creates better balance, but in this arrangement the objects are spaced so far apart that the composition is split in half.

In figure 7 the void through the center is filled in with the pitcher; however, it is too dominating, being too large and too centered and hiding too much of the bowl.

FIGURE 8

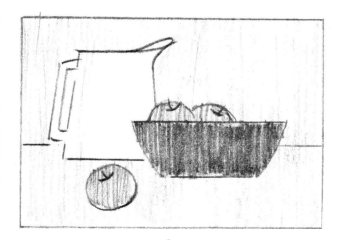

Figure 8 is a more comfortable arrangement, with the large pitcher placed in back of the smaller shapes. The general placement of things is varied relative to each other and the picture space. The sizes of the objects don't overpower the picture space, nor are they too small that they become lost.

THE PICTURE SPACE

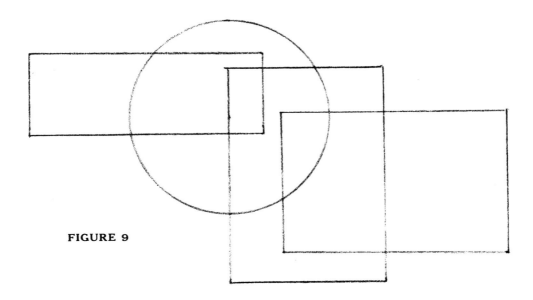

FIGURE 9

After we have an idea, the next thing to consider is the picture space, the area where we place the picture elements. Depending on your idea the picture space can be of any configuration. (Figure 9.) The most popular are the horizontal and vertical. Being gifted with horizontal vision, we are more comfortable with a similar format.

Selecting the right picture space for your picture is based on your own common sense, for the most part. For an example, see figure 10. The shape of a wide basket of apples will not fit well in a vertical format, nor will a tall thin vase (figure 11) be at ease in a horizontal picture space. Both examples are exaggerated to emphasize my point. However, there is no reason why you can't arrange the intended picture space just by changing the size of the object. (See figures 12 and 13.) In both instances more surrounding atmosphere has to be included.

The shape of the picture space in relation to the subject's size can express different feelings. We should choose a picture space wisely. Your decision should be as carefully thought out as the subject you have selected.

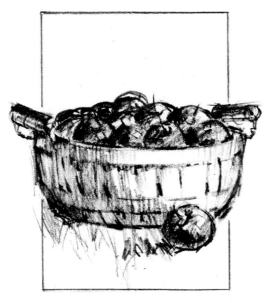

FIGURE 10

FIGURE 11

FIGURE 12

FIGURE 13

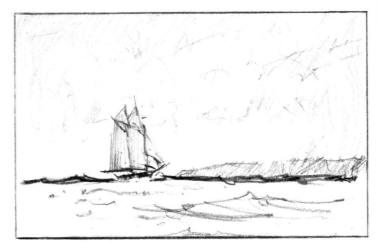

FIGURE 14

In figure 14 I wanted a feeling of open space, so I extended the width of the picture area and reduced the size of the ship to express my idea.

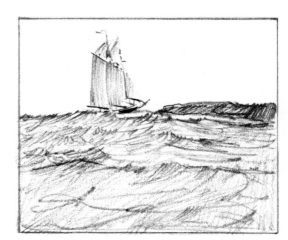

FIGURE 15

For figure 15 my desire is to convey the strength and power of the sea. I felt that a square motif for the picture space would be best. I let the size of the sea dominate in proportion to the other elements. In figure 16 my goal was to transmit an impression of insignificance: The sky towering over the ship. The vertical picture space with a low horizon gives great height and volume to the sky.

The final example, figure 17, is a horizontal picture space. The ship now fills the space; it is almost the opposite of the other compositions, where the ship is relatively small. This is good for an intimate close-up view. Finally, always be sure picture space and subject work together. It will help greatly in conveying your idea effectively.

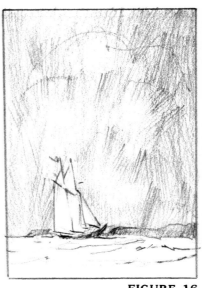

FIGURE 16

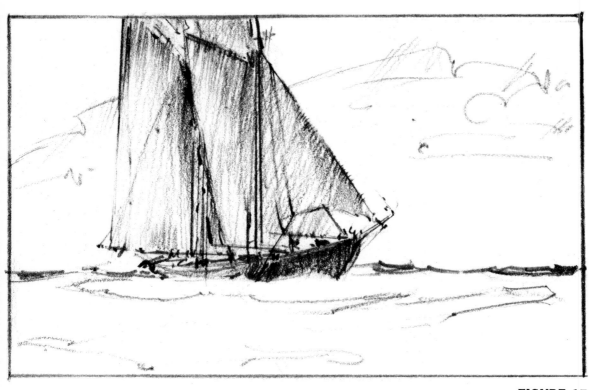

FIGURE 17

Nature Entices Pleasure, 18 x 24. *Collection of Mr. and Mrs. John C. Landry*

A walk through the woods of Nova Scotia one summer, to a coastal ship wreck, led to the discovery of these delightful falls. My young cortege retreated immediately for bathing suits. Here's a subject that could stand alone as an interesting composition, but the figures added interest. The two separate elements, the falls and the figures, would have to be unified as one. This is handled with a line of movements by incorporating the design of the figures with the falls. The line of movement starts, but can be picked up anywhere along its path, from the exiting gorge down in back of the figure's extended arm through to the base of the falls. The movement of the water at bottom right is then reversed to direct attention back up to the figures and impart movement back towards the falls. The design, even though subtle in parts, is not unlike the lower case letter "b". The placement and attitudes of the figures were arranged to flow with the river's design. Where I wanted less interest, I softened edges and used lower values, with less contrasts.

CHAPTER 4

SUBJECT SELECTION
AND YOUR CHOICE OF VIEW

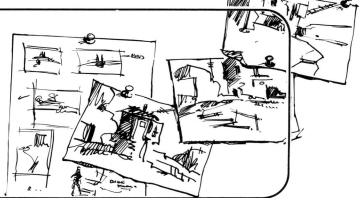

If you are a realistic painter your main concern is to record what you see; that's fine — but do you see *all* there is to see? Too often an unschooled painter is captivated by a scene and plunges right in to record it without pondering to see how it can be improved by adjustments of the elements — adjustments that will make it a better picture because it will be a more organized and more logically read composition.

I must say that I've seen very few perfectly composed first views offered by nature. There is almost always something that needs adjustment, and indeed there are other views to analyze that would possibly make your picture idea even more effective.

I believe that we should not be impartial recorders of nature, for a camera will do a faster and better job. Retain the emotional delight of your first sight — but then be a discerning artist who knows how to make a good thing better. You can adore your sweetheart — but it doesn't mean there's less love if you point out that her slip is showing or his socks don't match.

Remember, as a painter you are in *charge* of your picture. Your role is to observe nature and then *select* from it. Rearrange in any direction that satisfies you — if a tree is not exactly where you'd prefer it — shift it — and be glad you're an artist and not a nursery man! If a shape lacks character — is in a poor position — faces the wrong way — is too big or too small, take charge, change it just as you would a blouse or necktie that didn't suit you. Don't let Nature bully you!

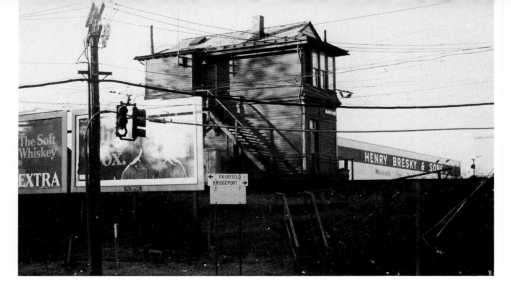

This is a place I've passed a hundred or more times and from the first sight, I thought it would make a fascinating subject to paint. I'll explain why later. The intersection is a busy one — the traffic allows no time for reflection, so I kept it in mind for a future possibility.

As a full time artist I look at everything as a possible subject; so, in the run of a day I observe and consider many potential picture ideas. It may be many months or sometimes years, as with the Burr Road Switching Station, before a subject finally gels. I weigh carefully what I'm going to paint. I just don't sail into the first impression I see. That first impression, however exciting, is still only a glint in my artist's eye. I want to spend more time and, as a comfortable friend, get to know its best sides, moods, facets and total character, so I'll be able to paint with *knowledge* and not just an impression of a superficial facade.

Let me take you through a step-by-step experience and wind up with my finished painted version. In this series of 4 photos you'll see what I saw and have the opportunity to agree or not with the picture logic I used to arrive at my final composition.

The first viewpoint is not always the best. However, before seeking another it is good to analyze the subject and its potentials.

My initial attraction of course, is the switching station itself. Why? First, its overall shape. It has a unique character, its proportions are unusual, identifiable for what it is. Above all it's not ordinary. So it will be interesting to paint and rewarding to view.

In addition to its shape there are secondary elements that help to support and to identify it as a specific place. There are also elements that hinder its character. The plus factors are the knoll that gives it grandeur and the fascinating way the stairs lead up towards the station. The minus factors are the straight-on static view. The billboard hinders the building's shape and the dull out-of-character background building needs to be removed. But before making a final decision I want to explore my subject from all other angles.

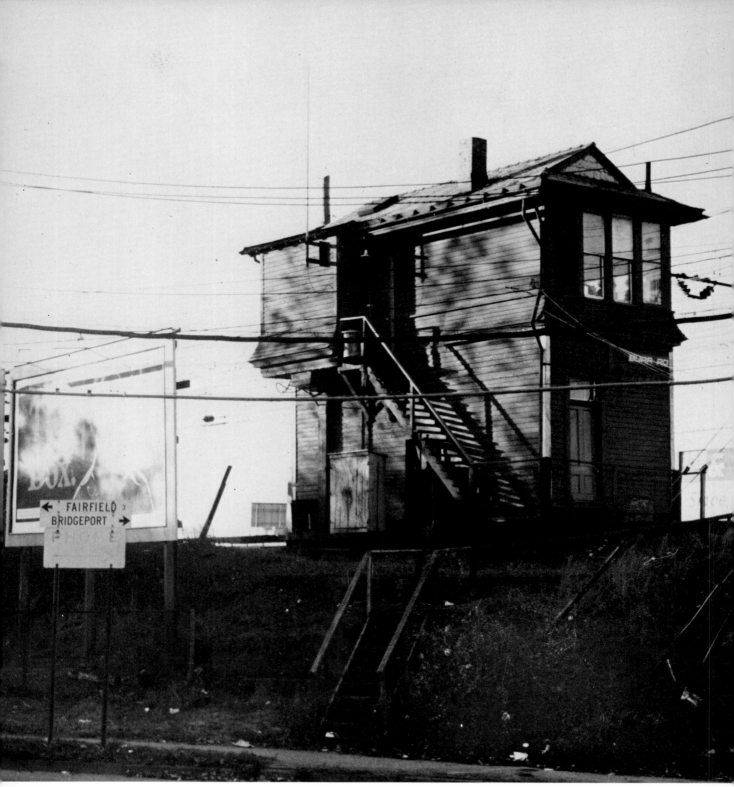

Photo 2

I've stepped more to the right and now the shape of the building is much better since the billboards are not blocking one side. From this ¾ angle the view has greater dimension and it has let me discover that interesting overhang at the back. How much more of a railroad building that detail makes it seem! There are, however, secondary elements to contend with. Even so, this view has greater potentials than the first.

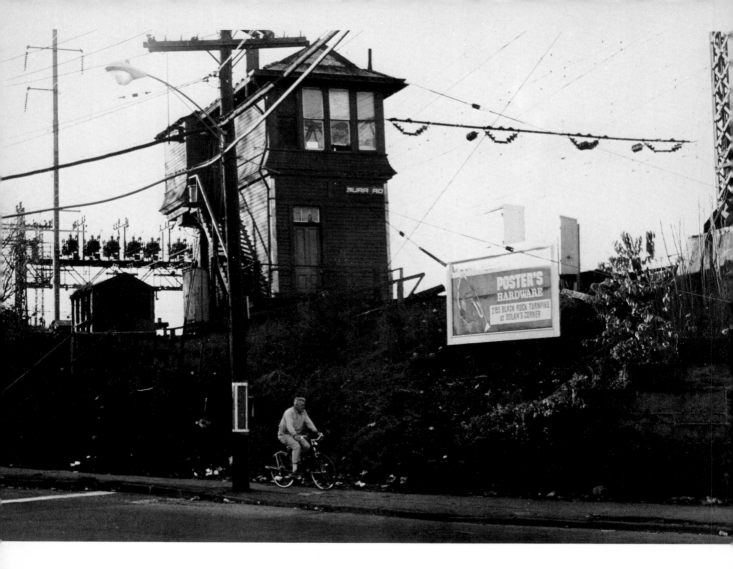

Photo 3

I continued to walk around my subject, and stopped at another point
of view. Although there is a crowding of the secondary elements because
of overlapping shapes, there is also a feeling of unification. The framing
of the building by the power line standard is effective but overpowering.
The foreground leaves much to be desired.

This was the last view I examined. It was also the poorest — but I didn't know that until I looked. Sometimes that last look makes the trip worthwhile. Note that this is the only one of the four views that reveals the oil drums. It so happens that I didn't wish to make use of them. But if it had suited my purpose, I would have had no compunction about painting them in where I wanted them. That's what I mean by rearranging "nature" — even when it's a motley man-made object like an oil drum.

Photo 4

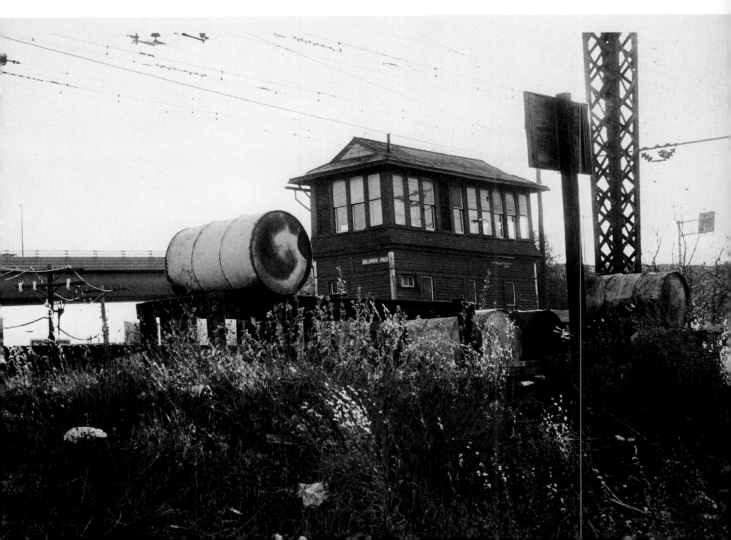

FINISHED PAINTING

I chose the second view. Except for the unification created by pulling together of small shadows on the building facing the observer; the configuration and lighting of the building were kept. The elimination of the background building is the most notable change, as I felt it was not in character with my idea — a lonely sentinel at break of dawn. The distant foliage in morning haze fills the void.

The foreground is the second major adjustment. I raised the knoll considerably to give the building majesty. The stairs were lengthened, of course, and the ascending design made more acute to contrast against the many horizontals in the arrangement. Small busy shapes were eliminated in the foreground to create a lonely starkness. The single small figure on the stairs also helps to create the intended illusion. Consider always, the use of the human figure in any landscape you do. There is no rule to be followed of course, only your sense of rightness can decide. If you use this painting as an example, I think you'll agree that it's been made better by the figure's inclusion. It does three things. It gives scale. It introduces a hint of story and it gives interest to the long monotonous stairs.

Burr St. Switching Station, 11 x 14 inches.

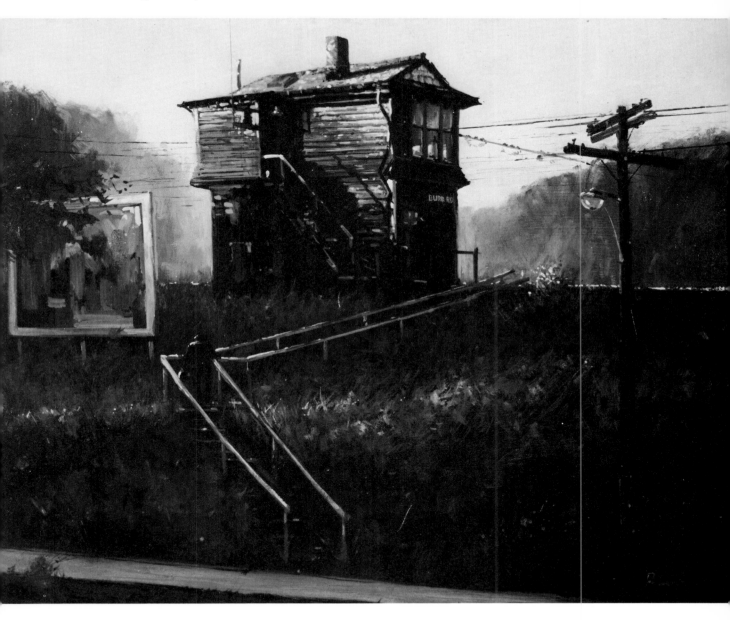

CHAPTER 5

PICTURE MAKING

I've titled this chapter Picture Making because it deals with the physical act of handling and preparing materials to make a picture. Every page and thought in the book has to do with picture making, of course: the application of knowledge, sensitivity, taste and a thorough familiarity with your tools and materials. To this must be added practice, dedication, exploration, an open mind and a never-ending pushing of whatever talent you were endowed with.

COLOR

The physicist deals with color in terms of light. The artist alas, must deal with color in the form of pigment, which has great limitations. We are unable to match natural light. Pigment for instance, cannot match the effect of luminous sunlight on a shiny surface, let alone the sun itself, or the blackness of a mine shaft. Paints are chemical mixtures: earths, clays and minerals joined by a binder. Each pigment is physically quite different from the other. Some are opaque, others translucent. Each behaves differently as you brush it on your canvas. After a while you'll learn through experience how to identify and handle the personality of each pigment. The scientific study of color as light and its physical make-up would broaden your knowledge, but I don't consider it essential for the artist.

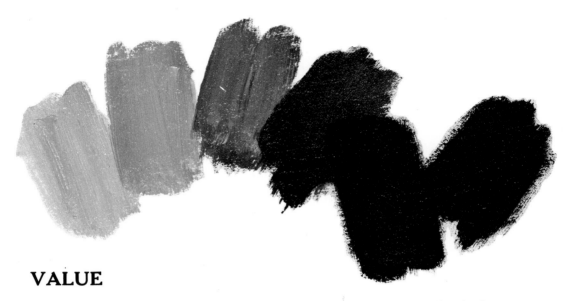

VALUE

Value is the most important property of color. Simply put, value is the lightness or darkness of a color. We distinguish a light and dark color in terms of white to black, in short, by its value. We change the value of a color by mixing it with a relative darker color to darken, and with a lighter color to lighten. An understanding of value is imperative to the painter. Think of it as tuning — the delicate adjustment of one color to another.

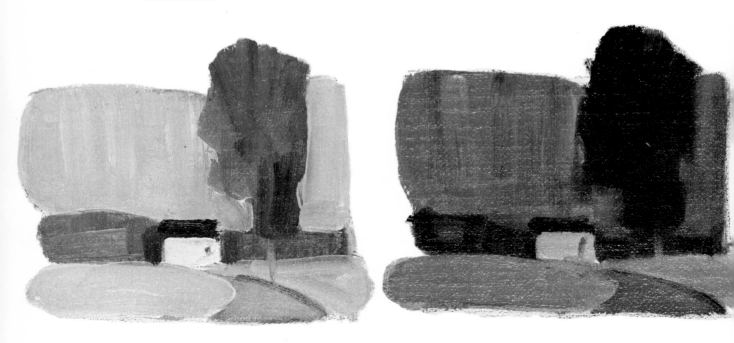

PROPERTIES OF COLOR

Color has three properties: Hue, value and intensity.

HUE

Hue refers to the name of a color. The sky is blue; an apple is red. We can change the hue of a color by mixing with another color. Mixing yellow with red creates an orange hue.

INTENSITY

Intensity is the third property of color and is next in importance to value. Intensity is the purity of a color. The intensity of a color is at its maximum as it comes from the tube. There is very little in nature that calls for color to be used in its pure state. It's up to you to decide how much to lower the intensity. It's usually achieved by adding grays of an equal value.

THE COLOR WHEEL

The color wheel teaches color theory, and it can also be useful for working out effective color schemes. It shows how to mix secondary and intermediate colors from three primaries. In most art instruction books more emphasis is placed on the color wheel itself, rather than the importance of controlling the properties of color. There are many and varied color wheels, ranging from simple to complex. In figure 1, I've illustrated the color wheel as simply as I could. As we go along, I'll refer back to it.

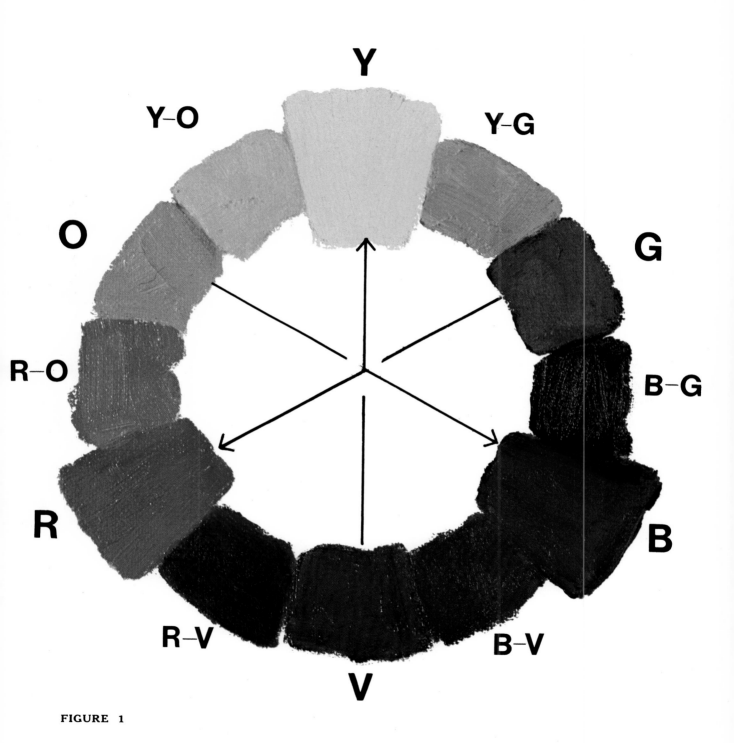

FIGURE 1

67

THE PALETTE*

Most artists palettes I see, contain too many colors. More does not necessarily mean better. With a limited palette you'll have better control, you'll gain thoroughness and speed, have greater understanding and you'll avoid frustrating errors. The following palette is a simplified one, based on observations through teaching, experimentation and personal preference. Your successful use of a personal palette will come with practice. My palette consists of eight colors plus black and white.

Cadmium Yellow Light
Cadmium Yellow Orange
Cadmium Red Light
Alizarin Crimson
Ultramarine Blue
Burnt Umber
Viridian Green
Manganese Violet
Ivory Black
Titanium White

Now you must learn how to control them. These colors are not listed in any logical order. They're not organized in terms of hue, value or intensity. We must learn to categorize them. The following exercises will show you how.

HOW TO DARKEN OR LIGHTEN A COLOR AND STILL HOLD THE SAME HUE.

The pigment I use comes from the tube to approximate the dark to light values in grays numbered from one thru seven. Consider this scale the Light Control Scale. (Hereafter referred to as the LCS) See figure 2.

Of all the colors, cadmium yellow light is the lightest value. Yellow is one of the primary colors. It relates in value to number *ONE* on the LCS. To darken the value of yellow, I use burnt umber. It compares to value number *SEVEN* on the LCS. Some artists darken yellow with its complement, violet, and some use black, which does change the value, but it also weakens the intensity. I always try to darken a color with color. Burnt umber is relative in hue to yellow so it is a logical choice. If

White

FIGURE 2

you want a middle value, number *FOUR*, mix equal amounts of yellow and burnt umber together; for the lighter or HIGHER range values, number *THREE* and *TWO*, add more yellow; for the darker or lower range values, *FIVE* and *SIX*, add more burnt umber. Squint your eyes to compare the color with the values in the light control. You may wish to add other colors, like cadmium yellow pale, cerulean blue, and yellow ochre. If so, relate them to the LCS.

Cadmium Red Light — Red is the second of the primary colors. As it comes from the tube, it matches value four (4) on the LCS. To lighten, add white; to darken, add another red, alizarin crimson. The alizarin crimson corresponds in value to number *SIX* on the LCS. Black is added to alizarin crimson to extend out the lower range.

Ultramarine Blue — Blue is the third and last of the primary colors. It is similar to value number *SIX* of the LCS. White is added for the lighter values and black is added to extend the lower range.

Cadmium Yellow Orange — Now we come to the first of the three secondary colors, orange. On the color wheel, it is between red and yellow. The value of cadmium orange relates to value number *THREE* on the LCS. To lighten orange, add white, and to darken, add burnt umber.

Viridian Green — Green is the next secondary color. On the color wheel it is between yellow and blue. Viridian green is similar to value number *SIX* on the LCS. For the high range lighten with white, and add black to extend the lower range. Manganese violet — As the color wheel indicates, violet is the last of the secondary colors. It is between red and blue. As it comes from the tube, the value of manganese violet is similar to value number *SIX* on the LCS. For the lighter value add white, and for the lower range, add black.

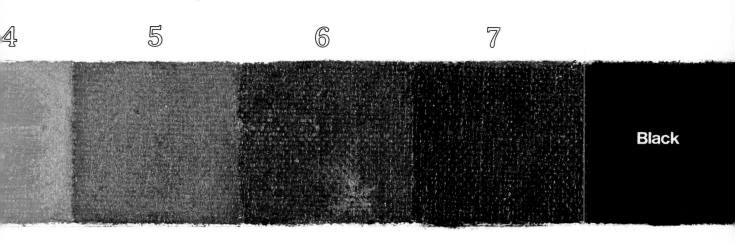

These exercises are meant to demonstrate the value range of the palette as pigment comes from the tube. I've demonstrated the three primary colors and the three secondary colors. From these, you can mix six intermediate colors. They are located between the primary and secondary colors on the color wheel. They are also related in name. Clockwise, they are: yellow-green, blue-green, blue-violet, red-violet, red-orange and yellow-orange. They too can be related to the LCS. For example, if you mixed green and yellow together in equal amounts, the value would be similar to a middle value on the LCS. To lighten, add white, and to darken, add related colors. A darker yellow, yellow and burnt umber; and a darker green, viridian green. Work at these exercises. You'll be happily surprised by your new knowledge and understanding. No more moaning after the mixing of mounds of unusable paint.

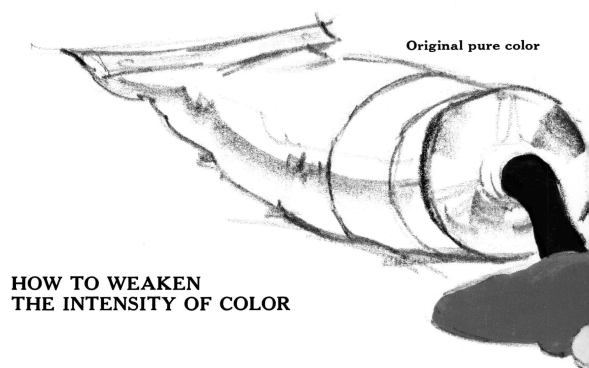

Original pure color

HOW TO WEAKEN
THE INTENSITY OF COLOR

Now that you are familiar with the value of color and how it relates to the LCS, we'll proceed to the method of weakening or graying the intensity of color. Colors in nature are quite subtle for the most part, so you'll continually find yourself needing to reduce the intensity of tube color.

To do that you can use either of two means: use complements or black. In using a complement to weaken the intensity of yellow, for example, add violet (opposite on the color wheel), provided you first match the value of the violet by lightening it. Thus, a weak yellow results. As for black, there are numbers of different blacks on the market. Some are warm and others are cool. Ivory black is warm. You usually needn't be unduly concerned with the difference, since you'll use it in such small amounts it matters little. Before you add black remember to lighten its value by adding white to match the value of the color to be weakened.

If you were painting an old barn a dull red, you would first mix the right value and then weaken the intensity of the red. The graying agent, would be black or the red's complement, green.

Color complement or black

White

PAINTING REQUIREMENT

It might seem superfluous in these days of dizzy prices to counsel anyone about caring for their tools and materials. If properly used and cleaned brushes become very cozy companions over the years. I still use brushes from my schooldays. They're in fine condition in spite of their mileage.

The most popular brush for oil painting is the bristle variety. There are many types on the market but I prefer the long hair flats. I find they have more resiliency between my hand and the canvas. You don't need a great supply of brushes but you do need a variety. You'll see the advantages as you get further into painting. For wash-ins (application of turpentine-thin red color) I use a 2 to 3 inch wide, but quite thin, bristle brush. My second choice is a long handled bristle-haired sash brush an inch or two wide. This is good for textural priming of your canvas and regular wash-ins. The regular brushes come next, both in long or short hairs. You don't need every size. For a limited variety I suggest skipping the odd numbers from one through twelve. You'll end up with seven to nine bristle brushes, including the wash-in brush that will handle the painting of any size canvas, (figure 3).

BRUSHES AND PALETTE KNIFE

I don't use a hand-held palette, I prefer a fixed one. I use a piece of plate glass fitted on top of my taboret. The taboret top is painted a neutral middle value gray under the glass. This makes it easier to compare value and colors correctly. The rectangular thumb hole palettes are popular with many people. They have a fair amount of working room and fit neatly into an outdoor sketch box. You will also need a palette knife for mixing. I prefer the trowel type. You should have a selection of the many types, some to mix paint, some to apply it, some to create surface textures on the canvas, (figure 3-A). Choosing an easel is a matter of personal taste and budget. If you can afford it, you should acquire a studio easel and an outdoor folding one. Don't skimp here. A rickity easel is very disconcerting. There are two basic surfaces for oil painting: the flexible type, stretched cotton or linen canvas, and rigid panels of canvas board, Masonite, or pressed wood. For the beginner, I'd suggest canvas board. It is acceptable and the price is much lower. Later, when you are more sure of yourself, step up to a stretched canvas.

In most cases, oil paint is not in its ideal state for use as it comes from the tube. It is usually too thick and dense. To correct this, and simultaneously quicken the drying process, you will need something called a medium. This can vary if you mix it yourself. Here are two popular mixes:

2/3 Linseed oil (art supply, not house paint variety)
1/3 Gum spirit of turpentine

Some artists prefer 1/3 linseed, 1/3 turp., 1/3 retouch varnish. There are also excellent pre-mixed mediums available at your art supplier.

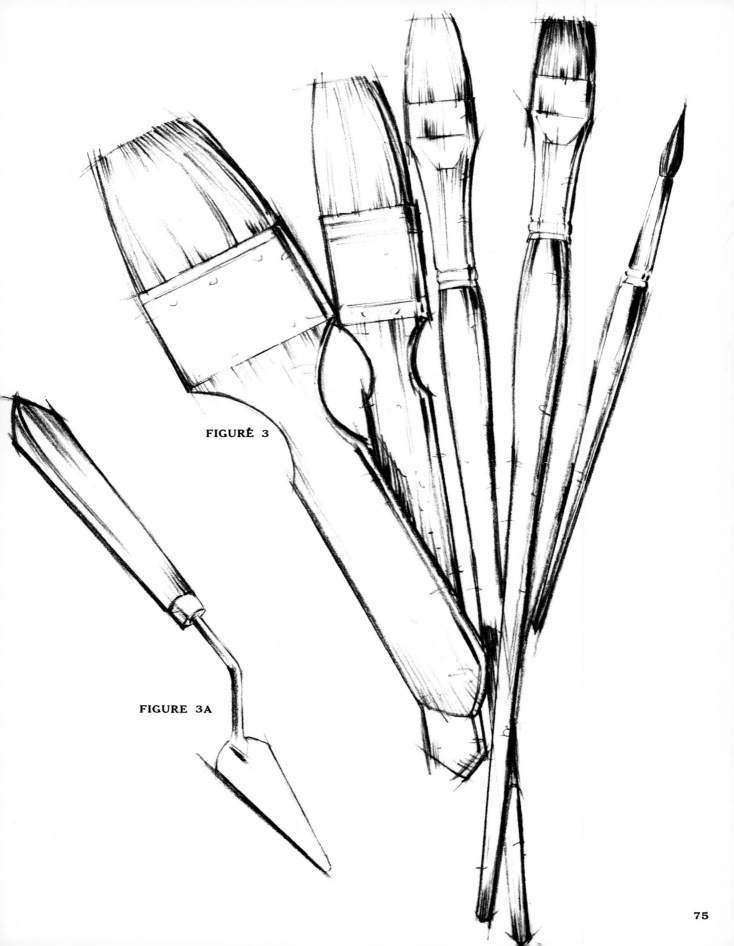

FIGURĒ 3

FIGURE 3A

PAINTING PROCEDURES

FIGURE 4

A good painting is a combination of drawing, conception, composition and color. The following demonstrations will show you how to put these elements together. This is a series of controlled steps, a simple working procedure that will hopefully diminish your frustrations and make painting more enjoyable for you.

In preceding chapters I selected a special subject and analyzed its possibilities from all angles. The painting I'll demonstrate now is really no particular place, but an amalgam of many bits composed into a unified whole. My children love to walk rock walls. For a happy memory of these days, I wanted to incorporate that idea with a New England landscape. Children, rock wall and general landscape were my elements. Figure 4 was my first thumbnail sketch (actual size). After that initial commitment I went on to many variations of my theme. Make it a practice to do this. Don't be content with your first concept. Adjust, rearrange, reconsider.

In these small composition sketches (figure 5) note that I'm not interested in detail, just the rudiments of my intention. I'm only concerned with shapes and line and their placement in relation to picture space. I may do from ten to twenty arrangements, exploring all kinds of possibilities, shifting my viewpoint, moving shapes and line for the right balance and movement. The best is selected and then refined. For example, I pull out the important elements like the barn and tree and probe its design possibilities (figure 6) and (figure 7). A day sketching trees and rock walls and just plain enjoying myself, as I acquire my pictorial ingredients. Figure 8 is a gesture sketch of the frolicking characters who inspired the idea.

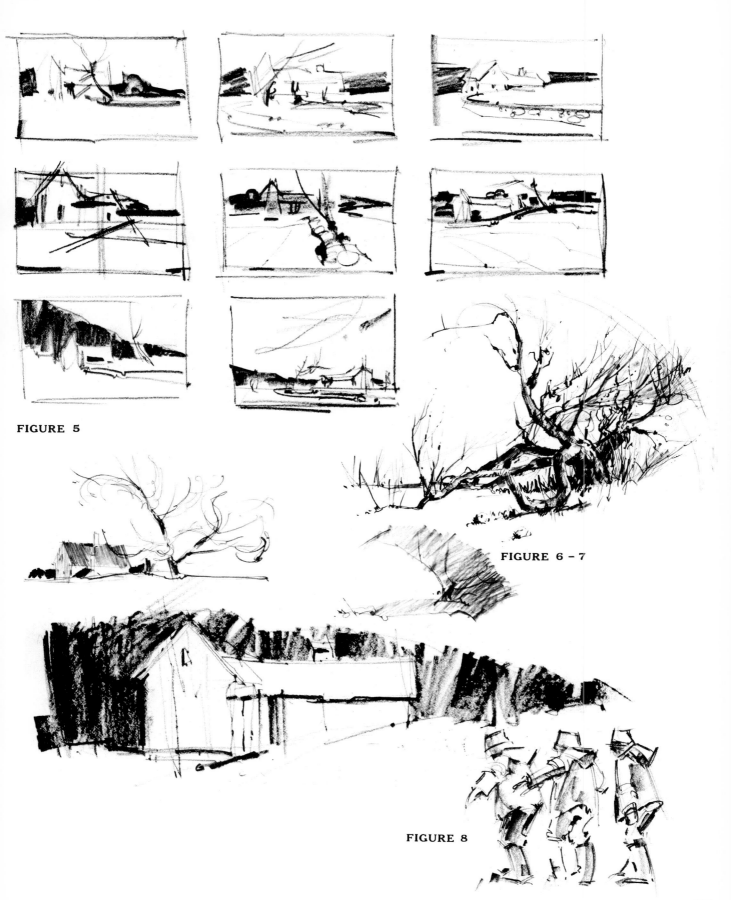

FIGURE 5

FIGURE 6 – 7

FIGURE 8

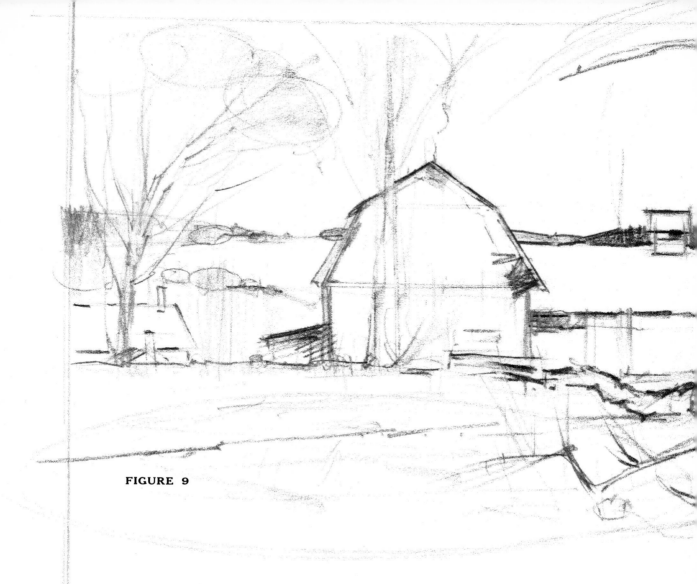

FIGURE 9

WORKING DRAWING

A horizontal picture shape, I thought, would be best for my subject in order to capture the atmosphere of a New England landscape. Then I related the drawing to it. In the drawing (figure 9) I was basically concerned with the boundaries of major shapes. The rock wall and apple tree were drawn with little concern for detail, like the rocks within the wall and small secondary branches. This working drawing is only 7″ x 10″. Over this drawing I made a simple grid on tracing paper (figure 9a). This will be used to enlarge and relate the drawing to the canvas.

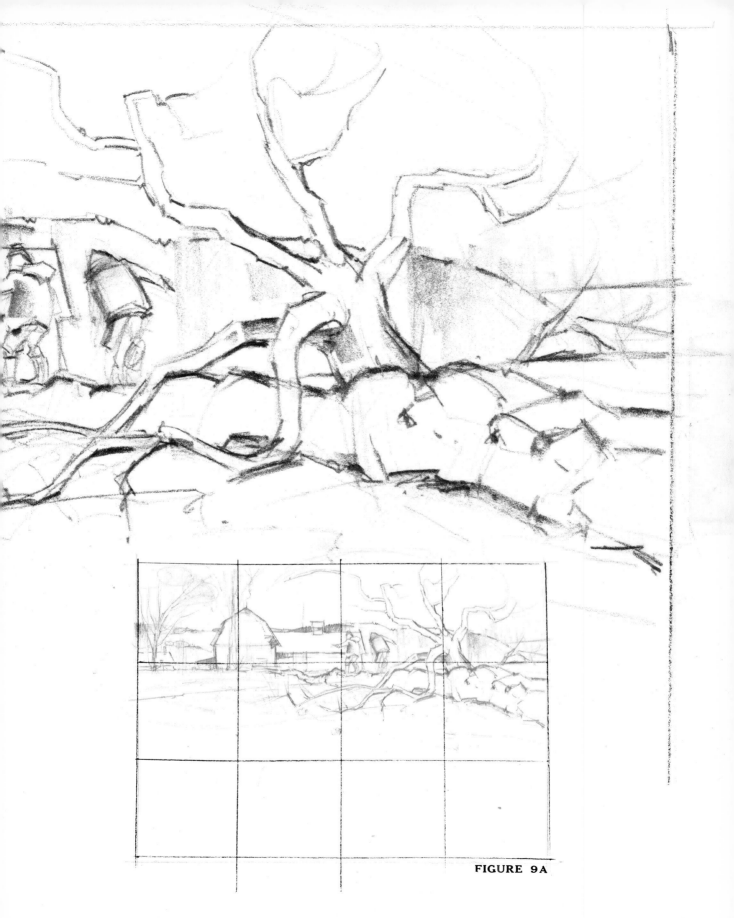

FIGURE 9A

PREPARING AND TONING CANVAS

Like many other artists, I like to prepare my own canvas or board. After stretching the canvas, I prime it by brushing on two to three coats of gesso. I paint the last coat thicker than the others, using varied brush strokes for textural effects of the grasses that will be worked in detail later. The gesso dries in a few hours, then I proceed with toning the canvas.

Toning serves two purposes. It provides an initial value to relate other values to. Working on a stark white surface makes it hard to adjust values. Secondly, I can use toning to key the color theme. In this instance, I wanted a late Fall-like sunny landscape so a mixture of burnt umber and orange were painted on with a wide brush, using lots of turpentine. The tone should be the consistency of a water-color wash. The value of the toning was made lighter than the middle value of the painting.

TRANSFERRING DRAWING

After allowing the tone to dry overnight, the drawing was transferred to the canvas. There are many ways to do this. Projection and tracing are two. I prefer making a simple grid on the canvas to relate to the translucent grid over the drawing. You can position shapes by pointing off on the grid lines. When I transfer a drawing, I use vine charcoal or a very soft pencil, so a kneeded eraser or a soft rag can be used for correction. Don't be concerned with detail at this stage. Be concerned with the major boundaries of shapes and design.

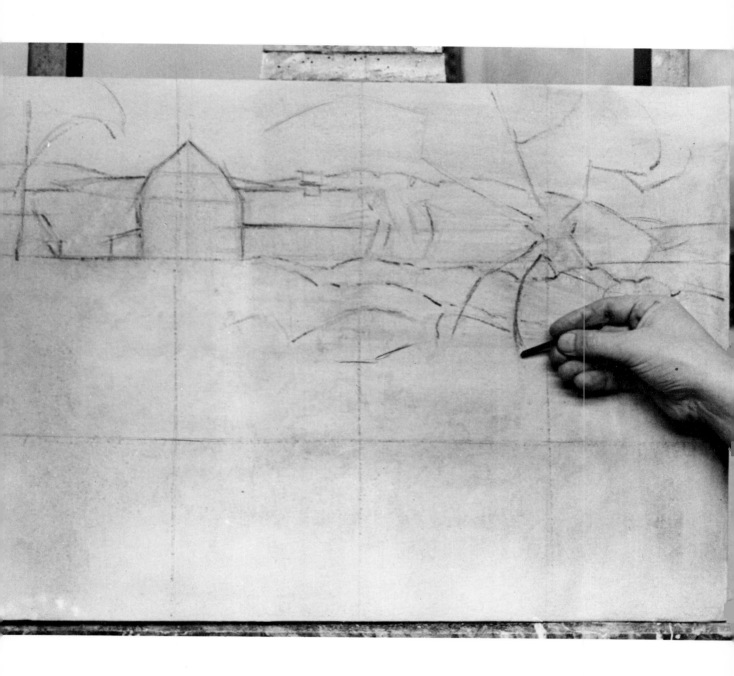

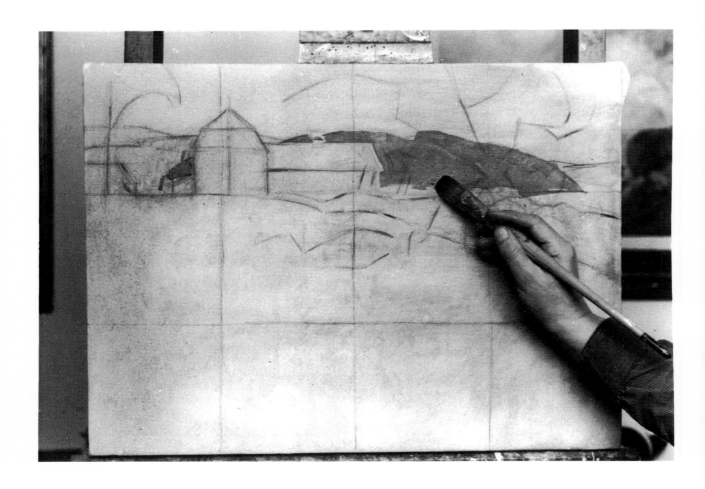

WASH-IN

First, I lightly spray workable fixative on the drawing to set it. After a few minutes for drying time, I begin washing-in the value pattern of the picture. I consider this the most important stage in the painting procedure. It is what I relate colors to, as I continue toward the finished stages of the painting. Still painting monochromatically (with a single color of several values,) I now establish the overall shape of the trees in back of the barn. The paint is still applied very thinly and with a large brush. It immediately establishes the overall shape of the trees and also the light shape of the barn.

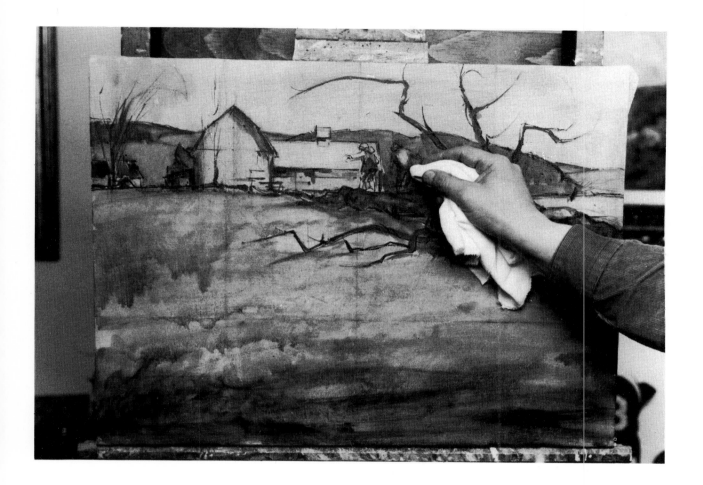

The major pattern of shapes in terms of their respective values is now established. I have worked from middle value through to the darkest shapes. Secondary areas can now be refined, like the foreground field. As you'll note, I don't try to smooth out washes. I flow them out quite freely and let them run where they may. I feel that painting should be free and interesting at all stages. I constantly give thought to the textural character of specific areas. I want some of this early spirited effort to show through in the final painting. Now I start to refine the drawing, especially the boundaries of shapes. A rag and turpentine are great for wiping out light areas.

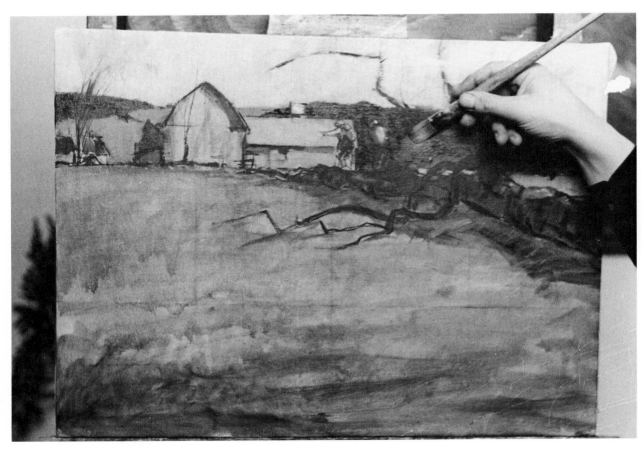

LAYING IN

Up to this stage I was working monochromatically. A full color palette was not needed. Establishing the positioning of elements and the value pattern were my main concern. Now that this is resolved, I can start relating color to the value of the wash-in. In this laying in of color I also paint very broadly. I usually start with the sky, as it is the source of light and the color that illuminates the landscape. Although I only want to lay in the specific hue, value and intensity of each area, I try to establish some of the character as well, rather than just paint flat shapes. The paint is applied thickly, about the consistency of whipped cream. No attempt is made to paint around details like the tree limbs. I don't worry about painting into, or even through, an area. And, I want some under washes to show through.

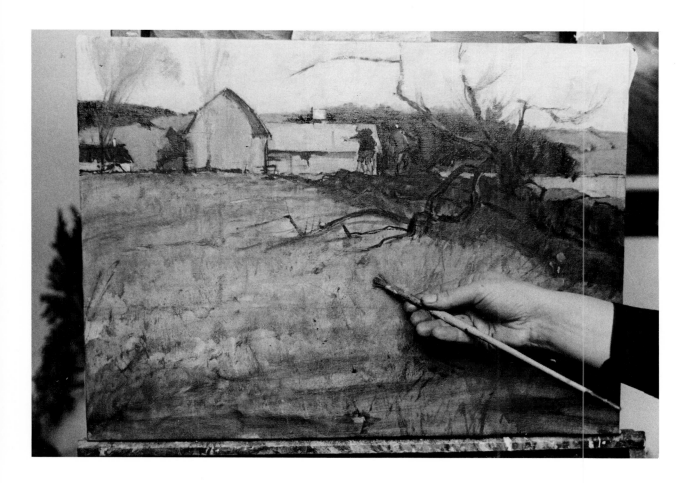

I have now completed the stage of relating the color of each area. This is not apparent in the black and white photo and the lay-in looks similar to stage four, the wash-in. This is because the color applied over the wash-in corresponds to the same value.

Like the wash-in, I try to keep all stages of painting interesting and look forward to the final stages. I now apply underlying textural character with an old brush for the foreground grasses that will be overpainted later on.

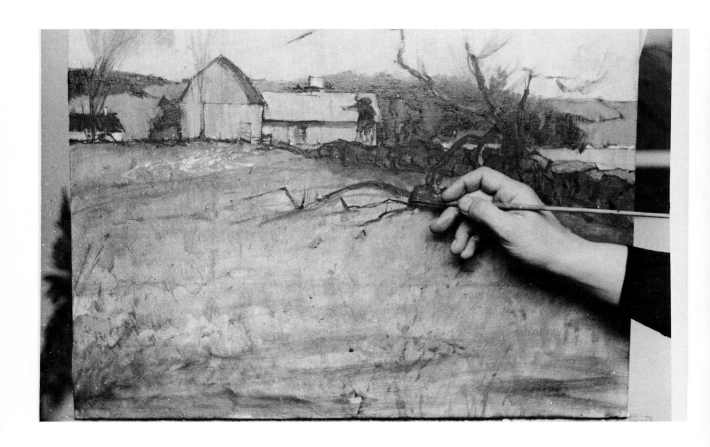

REESTABLISHING THE DRAWING

I feel that drawing and painting intertwine through all stages of painting. Many amateur painters feel that if they paint over their initial drawing they won't be able to draw it again. With that in mind they paint around and up to everything; the end result appears like a paint-by-number picture, with everything on the same picture plane. Shapes should overlap and merge with each other. This can't be accomplished without painting over and through things. In this photo I am redrawing the tree limbs over the sky and grasses that were painted over in the lay-in stage. There are always enough of the major shapes and design showing through to relate to.

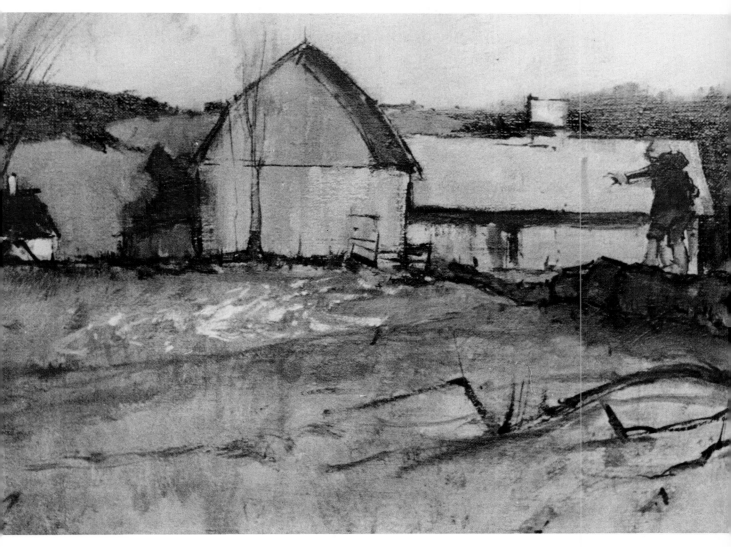

GOING ON TO THE FINAL STAGES

This is a close-up of just a part of the painting to this stage. The painting can be considered finished, but I personally like greater refinement. This includes making slight adjustments of value, edges and textures. The introduction of smaller shapes and greater detail can also be made. However, these should not go to the extent of fussiness and nothing should harm the initial value pattern of the painting.

CONTROLLING THE VALUE PATTERN

Turn back now to the Light Control Scale on page 10 and see how I've applied it to this painting. A full range of values were used in the following order. They were numbered for identification purpose only, from white to black. Number 1 value is the light source, the sky, which was painted first. Number 4 is the middle value, which in this case is the important binding design of the tree shapes. Number 5 is the darkest pattern of the picture which includes the rock wall, foreground tree and children. The final major value is the fields, number 2, and the barn, number 2, relating to the light scale. The lightest light, of course, is for the snow and the darkest dark, in the case of a sunlit outdoor painting, number 6. Number 7 was used for the accents of the rock wall and tree in the foreground.

New England Landscape 18 x 24

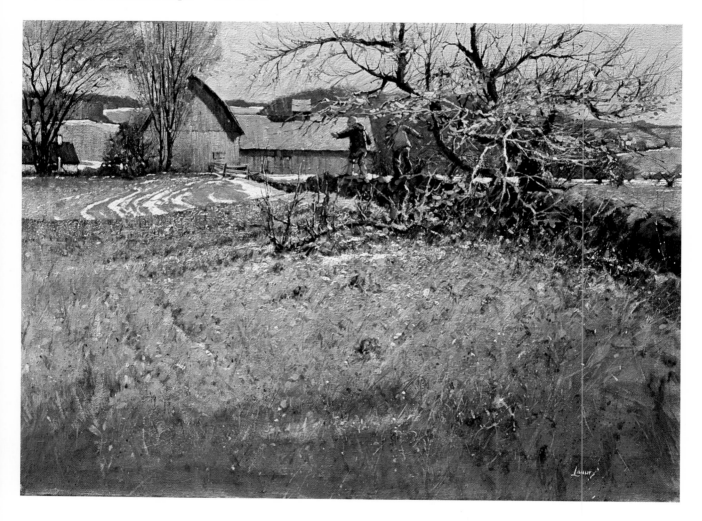

CHAPTER 6
THREE DEMONSTRATIONS
. . . a still life . . . a portrait . . . a landscape

Watching thin paint run down a canvas, seeing it being absorbed and observing shapes forming from the stroke of the brush is an exciting thing to me. Perhaps that means I should have been an abstract painter. No chance though, I'm a dedicated realist who takes artistic license.

Follow me now as I go through the steps of laying-in and then finishing a simple still-life. First I brushed on two coats of gesso for textural effect over an already primed canvas. Then I rubbed in refined linseed oil with a rag. I used just enough to slick the surface; this makes a wash of color go on easier and also enables you to wipe out to lighter values more easily. I'll demonstrate this in the next step. For the wash of color I used a mixture of viridian green and burnt umber with turpentine. This color will be compatible with my color scheme. It makes sense to establish this immediately. With a two inch wide brush I covered the whole canvas. (The photo shows me at the half way point.) The wash-in of the canvas serves two purposes: it establishes the relationship of values and the general color theme of the painting.

WASH-IN

A wash-in not only helps to relate values and to key the color scheme, it also gets rid of the overpowering glare of the white canvas. While the paint was still wet, I wiped down the canvas to a middle value. Here the darks are being painted again, using a mixture of viridian green and burnt umber. First note that I've located my center of interest, the vase of daisies. Since it's a light value, I've rubbed it out with a lintless cloth (cheesecloth is best), and then gone on to the dark pattern of shapes that are most important to establish. As you can see, no attempt was made for meticulous drawing. I'm more concerned with the "big" pattern of shapes and values. Note here how broadly and freely I've painted.

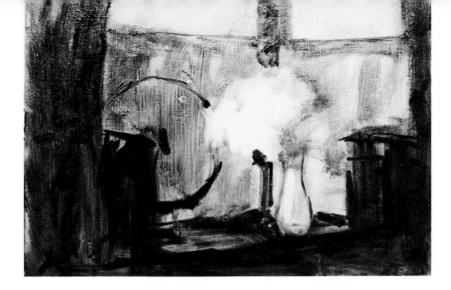

At this stage I want the paint to remain wet, (a wash-in should be completed in one session.) When wet, it is easier to wipe out to lighter values, move shapes around or alter them. The initial wipe of linseed oil helps to delay drying time and aids in the removal of pigment. This is an important juncture because the overall pattern of my painting is established here. This is my method: first, an overall wash for a middle value, then the dark, positive pattern of the curtains, ship lights and deeply shadowed foreground, combined into one overall shape. Finally, the light window shapes . . . essentially, three major values. The lightest light is saved for the center of interest — the flowers.

Here, I've refined the boundaries of shapes, have gone into them and established the lights related to the form. These were wiped out with a rag. The darkest accents were introduced. The wash-in is now completed. This is the stage of the painting where there can be a tendency to get carried away with detail. It is important to know when to stop. I shall continue to paint over the wash-in, time enough later for the details. I only go to a point now where it will leave me ready for the next painting stage. I usually let the wash-in dry overnight before going on to the next stage.

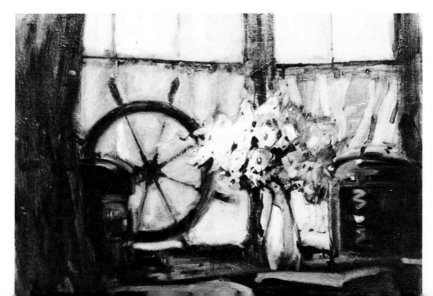

THE LAY IN

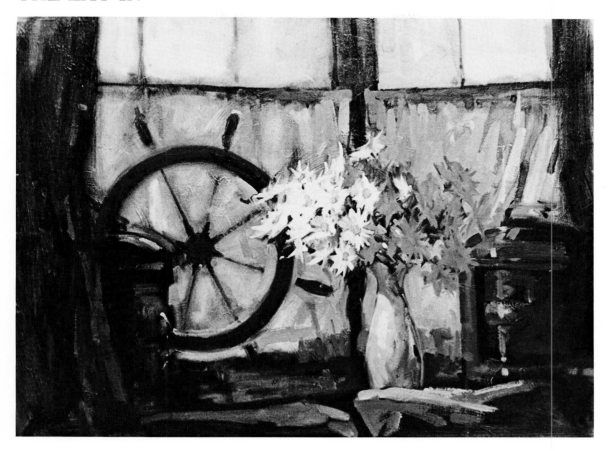

While a wash-in is monochromatic, (one color) the lay-in is the stage when you establish the overall color of the painting. The values have been established and now relating color can be easily controlled.

The wash-in is done with thin paint. With a lay-in the consistency, particularly from the middle values through to the lights, should be like whipped cream.

With the paint at that consistency I first painted the flowers, my center of interest. They are painted freely — there is more detail to come later. Note how spontaneously the curtains on the right and the ship light and foreground are painted. I use direct brush strokes and make no effort to smooth them out. The under wash-in, especially the darks, still show through. Observe how the lay-in color is directly related to the wash-in value. The left side remains to be layed-in.

When the lay-in is finished I leave it to set for a day or so, or until it feels tacky, but not completely dry. The overpainting must intermingle and begin to evenly dry with the underpaint of the lay-in.

In this photo the left half is in the lay-in stage; the right is overpainted and pulled together. You will note here, that I take little pain in going around small shapes like the ship wheel spokes and window sills. I paint right through them, leaving only enough to reestablish later on. Except for a few brush strokes, perhaps an embellishment of a bit of color, the right side is finished to a degree that pleases me.

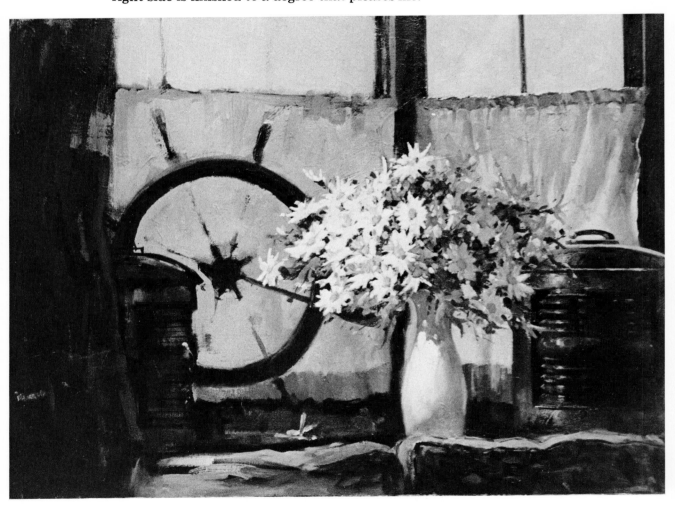

Studio Window 18 x 24

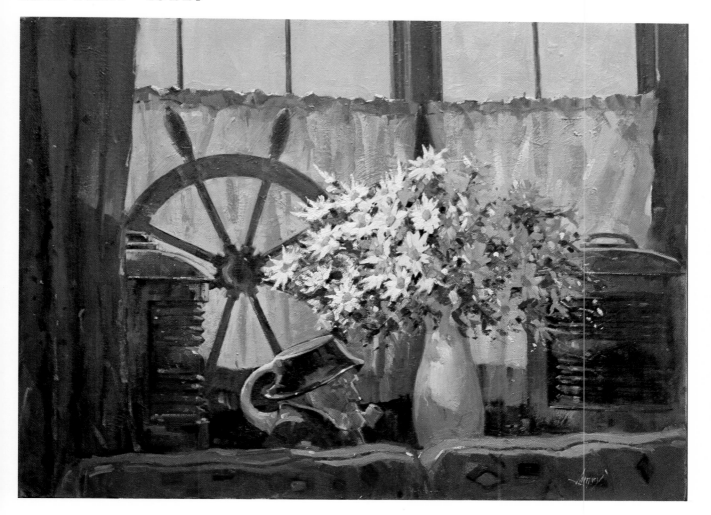

The Final Painting

This bay window in a former studio was always a favorite of mine. It
was ideal for setting up still-lifes and for the study of light. It would
catch the intense morning and evening light and everything in between,
including the subtle, filtered through, diffused light of overcast sky or
fog. The nautical objects in this picture were bartered for. The Captain
Ahab mug was loaned by a good friend for the duration of the painting.
This mug was added because I felt that area needed some interest. How-
ever, the value was kept close to the surroundings so the main interest
it still held for the daisies where the value contrast is stronger. You will
note even though the color is more intense in surrounding areas, like the
mug and shiplights, the value contrast will still dominate for the center of
interest. Especially note the softening of edges in the shadows and where
adjacent values are similar. This helps give the painting atmosphere.

DEMONSTRATION TWO . . . a portrait

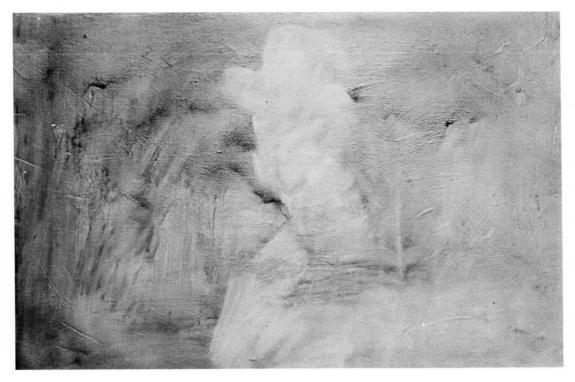

TONING

Although I usually progress in definite stages I do vary my working procedures within these stages for expediency. Here, after toning the canvas, I've wiped out the shape of my subject. Without drawing in, I wanted to establish the positioning within the picture space. I consider this just as important as the subject itself. If the positioning is not where I like it, I can just brush it over and reposition it with no time or drawing lost. Note what I've done to the overall texture of the canvas by brushing on gesso. I prefer this to the original monotonous weave of the canvas.

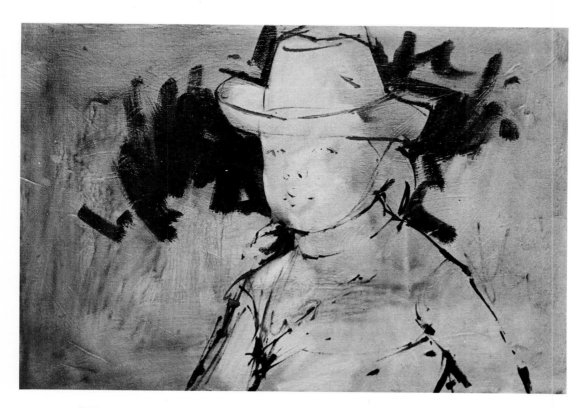

DRAWING

Now that I've positioned the subject within the picture space I can draw directly on the canvas, but I don't do a complete drawing. I only fix the main boundaries and proportions. This comes from careful relationship of shapes and line. The extension of line is important. When I draw, I try to extend a line as far as possible — one that goes to and from somewhere. For instance, I've used the continuance of line from the neck across the shoulder and flowing right down the arm on the right side. The suggestions of feature are for visual positioning, they'll be painted over as I proceed. I've begun the wash-in because I want now to observe the negative shape of my subject.

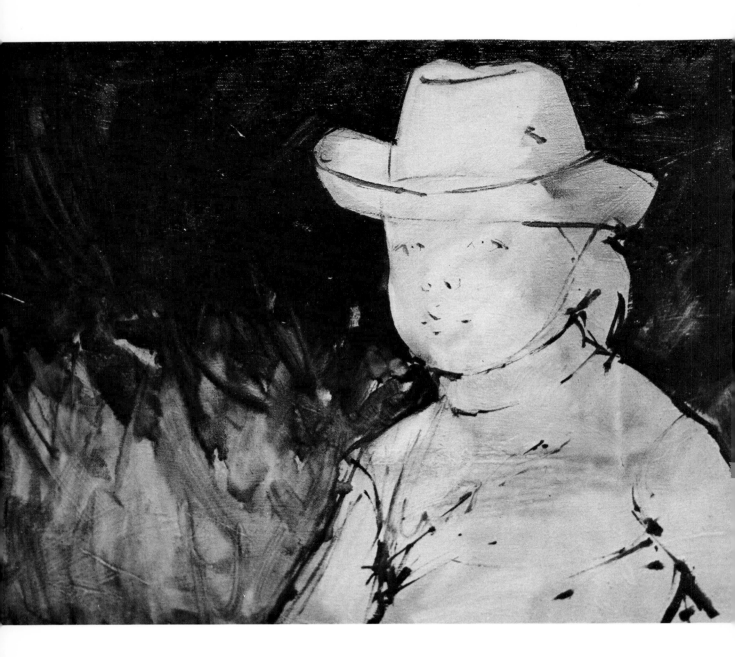

WASH-IN

The background here is completely washed in. In this painting I planned for a simple background, one that would be as spontaneous as my subject. The canvas had a receiving surface suited for staining. The ground was initially double primed, plus the two coats of gesso I added. A mixture of rectified turpentine and a small amount of linseed oil mixed with burnt umber was painted freely over the background area very broadly, and an interesting saturation effect was obtained. The bottom was painted more thinly for a gradation effect.

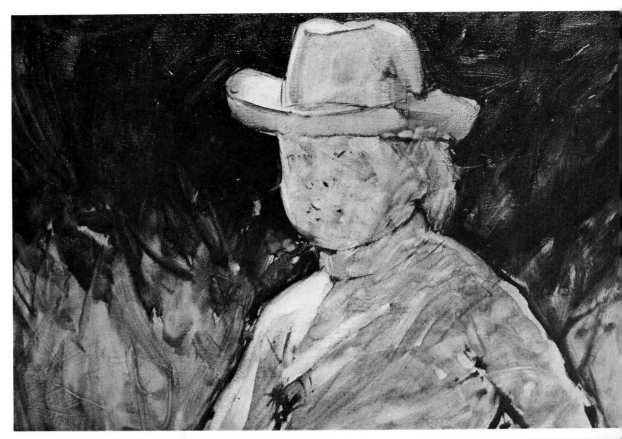

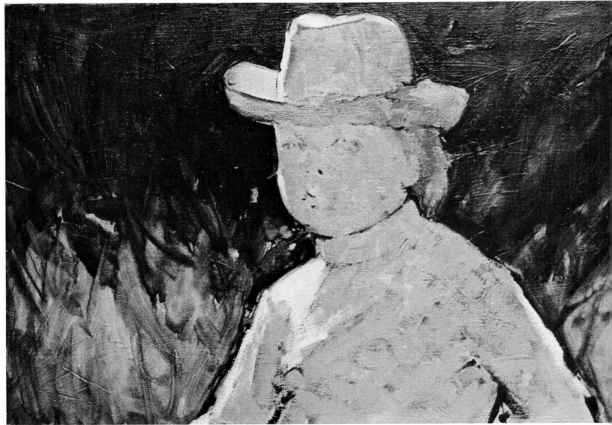

WASH-IN COMPLETE

My subject is outdoors and rim lit by the sun. The major value pattern was set with the painting of the background. A simple pattern of a light shape against a dark background. I established the shadow running down the figure by relating it with the lightest area of the background. The shadow could be similar but not darker, to hold the major pattern. A thin wash of burnt umber was used as it has a wide value range and the color works well with almost any color scheme. With a rag, I wiped out the light struck side, most noticeable here on the shoulder. The wash-in is now complete.

INITIAL LAY-IN

I always try to paint the known big areas first. For example, the background was painted before the figure in the wash-in stage. Since I'm not going to carry the background any further, I've laid-in the local color of the figure. The color was related very closely to the primary wash-in value. Although the hue and intensity are different under the hat, head and sweater, values are all quite similar. No form or detail is included in the initial lay-in stage. I painted flatly for a poster-like look, but free enough for interest. Note how some of the wash-in stage still shows through.

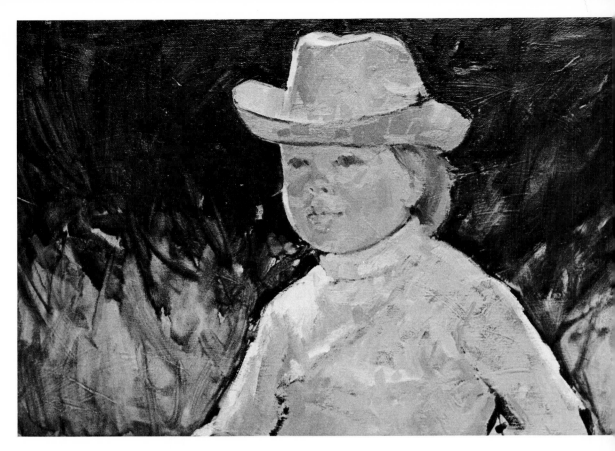

LAYING IN COLOR CHANGES

With the general effect complete, I can now start introducing color changes. This is a continuation of the lay-in stage. It's an important stage as I have to carefully control the value of hue without destroying the local value pattern of my picture. Although you can't see the color changes here, you can observe the definite brush strokes and slight value changes here in black and white, especially in the modeling of the face, the strokes going in the same direction as the form. The lay-in of color changes is stressed broadly. Note how the features are starting to take form. Just a few simple brush strokes are used at first.

This portrait is of our son Joey; it is obviously a labor of love. Knowing him as I do, it was easy for me to capture this moment. His favorite hat, a prized gift from his grandmother, set the color key of the painting. I posed him on a garden bench with the sun positioned high and in back creating a striking effect called rim lighting. With this lighting the subject is mostly in shadow, form appears less obvious, and it has to be painted very subtly. Local color changes are very apparent in outdoor shadows, quite evident in the face and hat here. The intense sunlight almost bleaches out these light-struck areas. The background was painted freely to match his enthusiastic nature. Although the face is finished to a high degree, the hat and especially the sweater were painted with abandon to help give the impression of his young spirit ready to spring off the bench and into action.

Joey 14 x 20

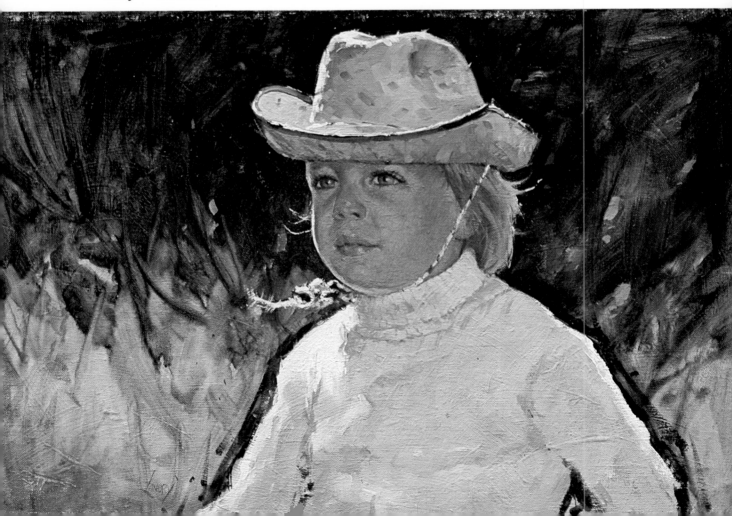

DEMONSTRATION THREE . . . a landscape

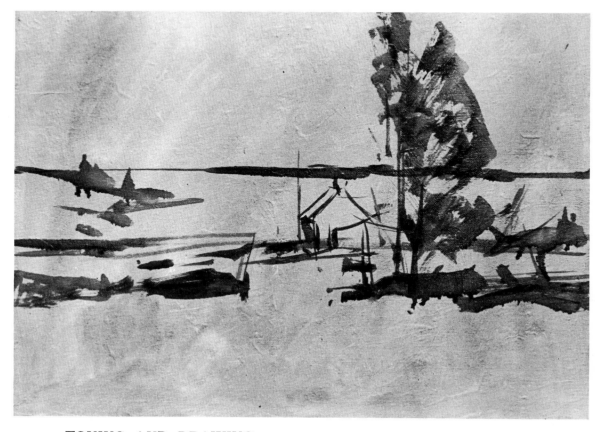

TONING AND DRAWING

This demonstration is about a direct method of application that is ideal for outdoor painting. Because of the size and a simplicity of subject matter, little time need be spent on preliminaries. Again, a burnt umber and viridian green mixture with turpentine was brushed over the canvas and then rubbed almost dry with a rag. Then, using a brush, I immediately drew in with a deeper mixture of the same color. This established the main division of space and positioning of the major shapes. Except for a few linear strokes for the horizon line and buildings, I used a wide brush to keep from getting involved with the small shapes and detail too early. If you paint freely with a large brush, the painting of shapes can also be more exciting. Here, it reminds me of Oriental brush work. The Japanese rely more on big interesting shapes to tell a story. Actually I could have stopped here — the impressionist scene is readable and I think successful as is. But I really wish to paint a different kind of picture.

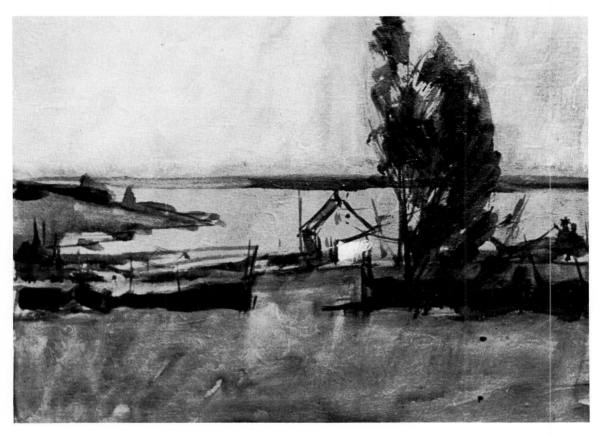

WASH-IN

The handling here of the wash-in is similar to the other demonstrations, in the fixing of the major value pattern in monochrome, with thin paint. I used a wider range of color and laid in some other areas at the same time. For example, with thicker white I established my lightest value, the buildings. The sky was then rubbed out to a value between white and the initial value of the toned canvas. With a dark green, I massed in the trees, using thin color. A mixture of burnt umber and blue was used for the wall. The value of the foreground grass can be easily related to a value between the original toning value of the canvas, still seen here in the water area and the dark masses of trees and wall. The major value pattern of my picture is set; four values plus white.

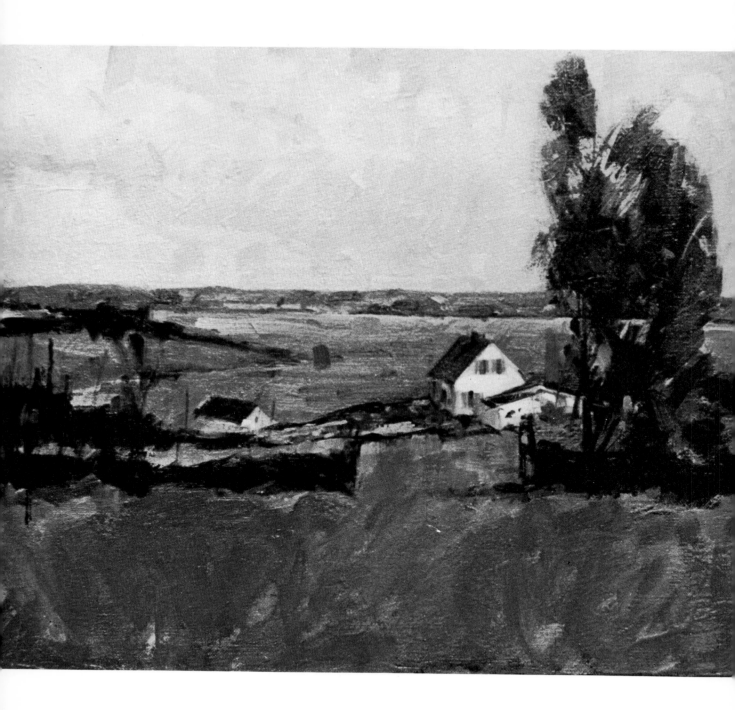

LAY-IN

Starting with the sky, I laid in the general color to match the established value. The cloud patterns are lightly suggested. There is no problem of the initial tone muddying up the sky blues. The wiping out in the last stage helped to dry that area. The distant land area is laid in next. I weakened it in intensity to help the illusion of distance. Also I related it to the intensity of the foreground washes in color. The large areas of water and foreground are now laid in with thicker color over the thin application of the wash-in stage. I am now starting to introduce smaller middle ground shapes, and refining the center of interest. If there is a question of a value adjustment in a major area it is best to make it in the lay-in stage. For example, I have lowered the value of the water area.

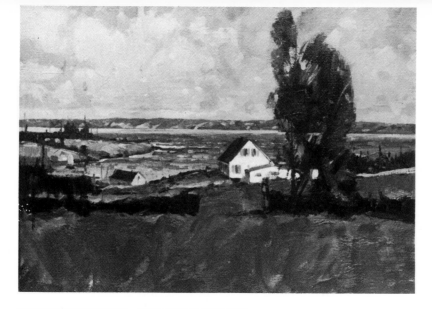

INTRODUCING REFINEMENTS

When you paint directly and continuously from a subject, you have to be careful of how far you carry it. The build up of paint can become unmanageable. The accidental pulling together of wet darks into lights can endanger the value pattern and color of the painting. That is why it is best, in this method, to paint thinly at first, adding thicker paint as you proceed. I most often complete landscape paintings in my studio, where I'm pleasantly freed from the weather, bugs or cold. At this stage I've worked the background into a finished degree but left the darker foreground values alone, especially the dark masses of foliage and rock wall that were quite wet. Introducing other color into these areas at this time would have created a muddy combination.

As a boy, I spent my summers on this farm in Nova Scotia. It faces a magnificent bay. At that time, the people living on the bay were self-sustaining, they lived a dual working life from the land and the sea. This is a rather simple subject, the center of interest, the farm house, and its supporting cast of landscape elements. The off center farm house with a unified tree mass against it is balanced on the left by the small building and evergreen trees. The general overlapping of foreground shapes against the middleground elements give unity to the arrangement. The feeling of atmosphere and height was obtained by the softening of distant edges, clouds included, and the extended shape of the tree. The pole gate drawn open invites one to come through the wild flowers and perhaps enjoy another view of the bay in its beauty. I suggest now that you go back and take another look at the first stage and the finished painting in early demonstrations. The reason for this is to let you see that the running "sloppiness" of the wash-in is thoroughly brought under control in the end.

The fastidious and orderly among you may be bothered by something you're not totally controlling in the beginning. Cure yourself of that needless neatness — it's important that you paint with abandon in the first stages. It is not only good for your spirit and the freshness of your approach but very important. The subtle build up of paint — the show throughs, and the very wielding of the paint will lead you to make better pictures.

Happy Painting.

St. Margaret's Bay 11 x 14

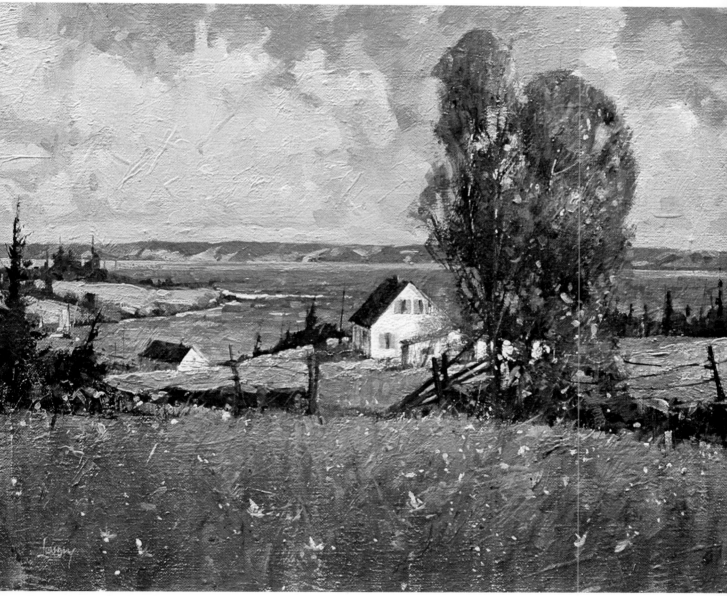